IMAGES
of America

LOS GATOS
GENERATIONS

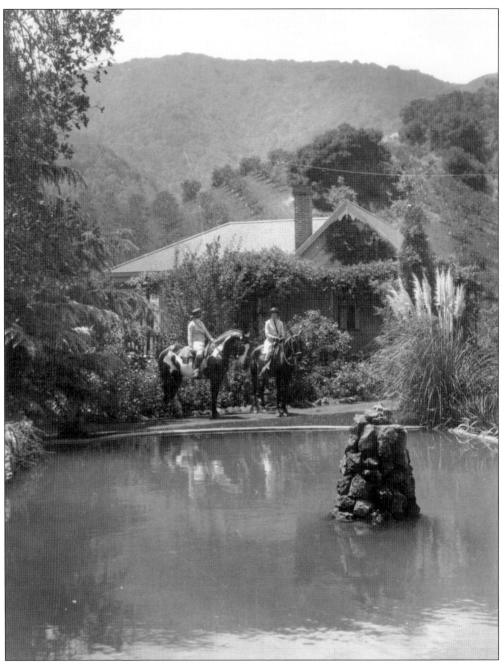

COUNTRY HOME IN THE FOOTHILLS. Published as a postcard by the H. J. Crall Company, this image by an unknown photographer depicts life in Los Gatos in the 1920s. (Courtesy Farwell family.)

ON THE COVER: The History Club of Los Gatos dates to 1897, when Elizabeth L. Urquhart, a local physician's wife, gathered six women together to study history, ancient and modern. In this *c.* 1925 photograph, taken at the clubhouse on San Jose Avenue, charter member Emily Cohen sits in the first row, second from the left. Author Ruth Comfort Mitchell stands in the third row, second from the right. (Courtesy History Club of Los Gatos.)

IMAGES
of America

LOS GATOS
GENERATIONS

Peggy Conaway

Peggy Conaway

ARCADIA
PUBLISHING

Published by Arcadia Publishing
Charleston SC, Chicago IL, Portsmouth NH, San Francisco CA

Printed in the United States of America

Library of Congress Catalog Card Number: 2007928546

For all general information contact Arcadia Publishing at:
Telephone 843-853-2070
Fax 843-853-0044
E-mail sales@arcadiapublishing.com
For customer service and orders:
Toll-Free 1-888-313-2665

Visit us on the Internet at www.arcadiapublishing.com

For Chuck

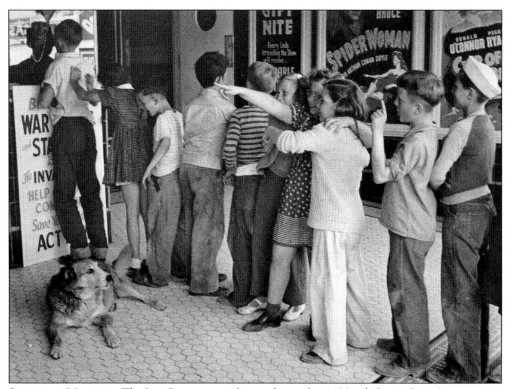

SATURDAY MATINEE. The Los Gatos movie theater, located at 41 North Santa Cruz Avenue since 1916, is pictured here in 1944, when it was called the Premier. Chief, the town dog, is keeping a watchful eye on the kids.

CONTENTS

Acknowledgments 6

Introduction 7

1. Prelude: 1840–1880 9

2. Toil, Trouble, Transcendence: 1880–1899 27

3. No Small Ideas: 1900–1919 57

4. Between the Wars: 1920–1939 91

5. The Growth Years: 1940–1959 113

Acknowledgments

I offer humble and hearty thanks to all who assisted me in my efforts to capture the essence of generations in Los Gatos: Carl Ambrosini, Marian Cilker Armstrong, Barbara Baggerly, Brian Bergtold, Phillip Bergtold, M.Sgt (Ret.) Joseph P. Bowman, Frank Burrell, Nadine Caperton, Audreyanne Castellucci, Alice Scott Fink Chappell, Stan Chinchin, Lena Barbieri Conley, Paul E. Curtis Jr., Lyn Dougherty, Linda Dydo, Betty Jones Ermert, Jason Farwell, Ron Fink, Bruce Franks, Capt. (Ret.) Duino Giordano, Bob Hill, Beatrice Cilker Hubbard, Ed Kelley, Mary Balch Kennedy, Pat Nash, Seval Oz Ozveren, Geraldine Jones Peters, Joyce Macabee Ridgeley, Scott Rose, Margaret Yocco Ross, Carleen Schomberg, Dr. Susan Shillinglaw, Dick Shore, Martin Shore, David M. Shuman, Eleanor Sussman, Claudia "Sunshine" Tomlinson, and Linda Ward.

Thanks also to the following: Peter J. Blodgett, H. Russell Smith Foundation curator of Western Historical Manuscripts at the Huntington Library in San Marino, California; Kathy Cusick and St. Mary's Catholic Church; Mary Hanel, local history librarian at the Santa Clara City Library; Bob Johnson, California Room librarian at the San Jose Public Library; Waverly B. Lowell, curator of the Environmental Design Archives at the University of California, Berkeley; Sara Morabito of the History Club of Los Gatos; James R. Reed, archivist at History San Jose; Dick Sparrer, editor of the Los Gatos Weekly Times; Sstoz Tes of the Martha Heasley Cox Center for Steinbeck Studies at San Jose State University; and Nancy Wark and the Los Gatos Chapter of the Daughters of the American Revolution.

These organizations contributed images: the Bancroft Library at the University of California, Berkeley; the Los Gatos Parents' Nursery School; the Oregon Historical Society; and the We and Our Neighbors Club.

Special thanks are extended to The Museums of Los Gatos. Many photographs in this book were scanned as a result of a partnership between the museums and the Los Gatos Public Library.

Finally, there are a number of people who made unique contributions to this work: Chuck Bergtold, who generously shared collections gathered during 35 years as an antiques dealer on Main Street; Gloria Bergtold, who suggested the "generations" concept; Joseph P. Doetsch, age 100, who sent photographs and shared crystal-clear memories of his Los Gatos youth; Melita Kelly, great-great-granddaughter of Jose Maria Hernandez and Maria Gertrudis Cibrian, who provided a direct link to El Rancho Rinconada de los Gatos; Paul Kopach, who serves as Los Gatos Library's history librarian; Beth Grover Rondone, age 97, who told fascinating stories of Los Gatos in the 1920s and 1930s and of the noteworthy people who lived here; and Elayne Shore Shuman, whose roots go deep into Los Gatos history, and who has made special efforts to preserve that heritage.

Thank you all.

INTRODUCTION

Los Gatos is a romantic spot. The earliest written references to the area describe park-like groves of oak trees on the valley floor, with redwoods rising like towers in the distance. The living waters of Los Gatos Creek, rich with silvery speckled trout, tumbled down from the mountains, and nearly anything would grow in the soil. Author Ruth Comfort Mitchell described the climate by saying, "Winter is spring, and it is summer the rest of the year."

The Ohlone Indians occupied the land for thousands of years. Before the Americans came, California was ruled by Spain, and then by Mexico. The Mexican era (1822–1846) was the age of the great ranchos and the dons. It is remembered as a time of graceful living in a good land. Californios Sebastian Fabian Peralta and Jose Maria Hernandez built a home on their 1840 land grant, Rancho Rinconada de los Gatos. Several Los Gatos pageants of the 1920s were set during the rancho period and presented an idealized view of a misty, graceful time of hospitality, sociability, music, dancing, and fine horses.

The Peraltas were one of the original colonial California families. Patriarch Gabriel Antonio Peralta, born about 1731 in Sonora, Mexico, came to Alta California as a corporal in the Juan Bautista de Anza Expedition of 1775–1776, accompanied by his wife and four children. In 1807, his son Luis Maria Peralta (1759–1851) was appointed *comisionado* (the highest ranking official) of El Pueblo de San Jose de Guadalupe. Luis was granted the 44,800-acre Rancho San Antonio in 1820 in recognition of his 40 years of military service to the king of Spain. Sebastian Peralta (1794–1859), co-grantee of the Los Gatos rancho, was Luis Peralta's nephew.

Little is known of the Hernandez family's progenitors. Jose Maria Hernandez served as a soldier at the San Francisco Presidio and was married twice, producing 14 children. Many Hernandez descendents are living today.

California history begins to come into sharper focus after gold was discovered in the Sierra foothills in 1848. The land was awash with men seeking fortunes in the goldfields. Some realized the value of the fertile land and came to places such as Redwood Township, later known as Los Gatos and its environs.

Many came to California by sea, including James Alexander Forbes, the Lyndon brothers, and Capt. J. D. Farwell. Thousands migrated west in covered wagons pulled by oxen, as did W. C. Shore and the Jonathan Parr family. Once they arrived, most stayed. They planted wheat first, before the land was largely given over to raising fruit. "There will be money in prunes!" they said. Tons of prunes and other fruit were harvested each year in the Santa Clara Valley, and the richness of the land seemed inexhaustible. By 1900, fruit ranches of 10–20 acres were the norm.

Many of those who settled on the western cusp of the valley were remarkable people. A young Englishman named George Seanor built a large blacksmithing business. In 1885, he constructed a 600-seat opera house on East Main Street, with box seats and dressing rooms, only to have it burn down in 1890. In 1892, his sawmill south of town met the same fate. Benjamin Franklin Bachman, who arrived in Los Gatos in 1880 and purchased a choice 50 acres of land, was a member of the Mariposa Battalion in 1851, when they became the first white men to see Yosemite Valley.

He was a bachelor who always wore carefully washed overalls when he walked down to the hotel every afternoon at 4:00 p.m. for a card game, carrying a lantern to light his way home.

The Bohemian enclave of C. E. S. Wood and Sara Bard Field must have seemed an enchanted realm in the rarefied air of their estate, The Cats, but the townspeople knew little of the difficult, entangled lives Wood and Field had lived. John Steinbeck came to town long enough to write *The Grapes of Wrath*, but he left when it became too noisy. Charles E. Christman obtained a patent for his very early automobile, built with California oak frames, in 1901. He rode it into town, and the locals said it worked to perfection.

There were terrible murders and an 1883 Vigilance Committee lynching off the new Main Street Bridge. The Ku Klux Klan even made a frightening appearance in town on the night of May 20, 1922. According to both the *San Jose Evening Times* and the *Los Gatos Mail-News*, seven men in full regalia entered the pageant grounds, "their auto siren screaming and their white robes streaming in the breeze." It was late, and the pageant cast had just finished rehearsal, which was followed by a picnic supper and a bonfire. The large black touring car circled the amphitheater, giving the actors the scare of their lives. Eight men clambered into two "machines" and gave chase through town at 50 miles per hour.

The town burned down twice, in 1891 and 1901. There were fatal railroad accidents, runaway horses and rigs, and fierce Prohibition battles. Earthquakes struck in 1868, 1870, 1906, and 1989. In 1877, the creek turned into a mighty river, burying some land under 10 feet of water. Other destructive floods included those in 1889, 1911, and 1955. During the Great Depression, "traveling men" slept under the Main Street Bridge, in boxcars, on planks under the freight shed at the depot, and at hobo camps set up along the creek on the east side of the canyon. J. D. Farwell donated a house for shelter, and Lyman Feathers set up his "hotel."

Through all of that and more, great books were written, important inventions invented, and pride in the community sustained. The human spirit overcame the troubles and challenges of the basic human condition, and Los Gatans were buoyed by the beauty of the land and by the privilege of living in this place.

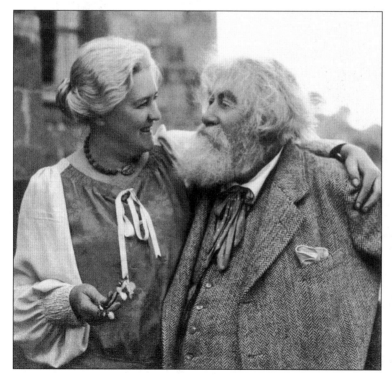

A COMPELLING LOVE. Sara Bard Field (1882–1974) and Charles Erskine Scott Wood (1852–1944) are pictured at The Cats estate shortly before his death. She was a poet and suffragette, and he a brilliant lawyer and genteel anarchist. Wood called their relationship "blessed insanity" and said, "I'm glad I did not die until I knew of it." (Courtesy Huntington Library, San Marino, California.)

One

PRELUDE
1840–1880

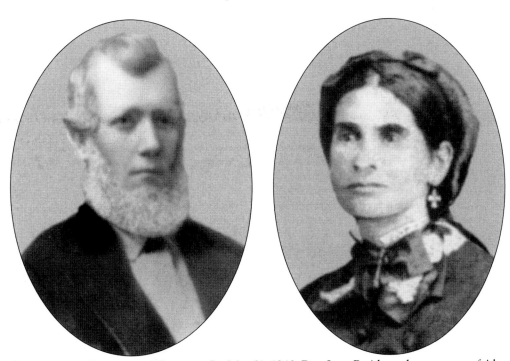

STEPHEN AND FRANCISCA WORDEN. On May 21, 1840, Don Juan B. Alvarado, governor of Alta California, approved the petition of Jose Maria Hernandez and Sebastian Fabian Peralta for 6,631 acres of land to be known as El Rancho Rinconada de los Gatos. Court records indicate that the men "had a house upon the land" even before the grant was made. Hernandez, who was born in 1808, married Maria Gertrudis Cibrian (1810–1852) at Mission Santa Clara de Asis in 1830. The oldest of their nine children, Maria Francisca (1831–1910), is pictured here in the late 1850s with her second husband, Stephen J. Worden (1820–1890), whom she married in 1858. (Courtesy Melita Kelly and Santa Clara City Library.)

THE HERNANDEZ FAMILY. Few photographs exist of those who lived on the old rancho. This photograph of Maria Francisca Hernandez Filzon Worden, the "first daughter" of Los Gatos, was taken c. 1870. Francisca married a Frenchman named Filzon at age 17, but tragedy struck in 1852 when thieves came to the rancho and killed the hired man, an Indian boy, and Filzon. Jose Hernandez, Francisca's father, left the rancho not long after, when his wife, Gertrudis, died in childbirth at age 42. He sold his land to James Alexander Forbes and retreated to Rancho Monte del Diablo, owned by Don Salvio Pacheco, one of his wife's cousins. The town of Concord was established at the center of that rancho in 1868. The 1870 federal census shows Jose Hernandez, age 63, living in Concord and working as a laborer. He was married to his second wife, Espalation, and they had five children. The 1900 census indicates that Francisca, again widowed and living in Concord, was the mother of 10 children, 9 of whom were still living. She owned her house mortgage-free. (Courtesy Santa Clara City Library.)

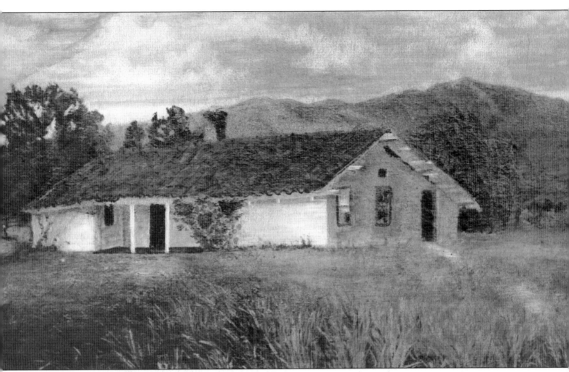

LOS GATOS ADOBE. The first house built on the rancho, shown here, was located in what is now Vasona Park, close to Los Gatos Creek and Roberts Road. Constructed as early as 1835, it was occupied by the Hernandez family and by Sebastian Peralta, a widower. This house and the surrounding 114 acres were acquired in 1865 by John Jackson Roberts (1824–1889), a veteran of the Mexican War who came to California for gold in 1849. He lived there with his wife, Martha Colter Roberts, and their 10 children. In 1931, two Hernandez grandchildren recorded their memories. Both Michael S. Worden and Hannah Hall Gonzales remembered that the old adobe had numerous "peepholes" in its thick walls, through which Jose Hernandez could look out and position his rifle. Fences tied together with cowhide straps did not prevent Native Americans from stealing the rancho's horses, and grizzly bears sometimes approached in search of food. A member of the Roberts family painted this image from memory long after the adobe was torn down.

THE PERALTA FAMILY. Born at Mission Santa Clara, Sebastian Peralta was a soldier at the San Francisco Presidio from 1819 to 1822, where he participated in expeditions against the Native Americans. He also served as a regidor (councilman) in San Jose in the 1830s. His first wife was Maria Gregoria Cibrian (1806–1837), sister of Gertrudis Cibrian Hernandez. In 1846, he married Maria Paula Sepulveda Pacheco, who was born in 1807. The couple built a new adobe, the second house on the rancho, to the north. In an 1899 *San Jose Daily Mercury* article, some who remembered Sebastian Peralta characterized him as "a lazy, shiftless fellow" who never had money unless he sold a steer. Yet rumors persisted for many years that he had buried a cache of $50 gold pieces under his adobe. According to court documents, Peralta could not sign his name; he made an "X" after his name, as seen here.

LUIS MARIA PERALTA ADOBE. This 1797 building on West St. John Street in San Jose is the last vestige of the Pueblo de San Jose de Guadalupe. The original builder was probably Manuel Gonzales, an Apache Indian. After Gonzales died in 1804, the property was passed on to Luis Maria Peralta, who was an uncle of Sebastian Fabian Peralta, a co-grantee of Rancho Rinconada de los Gatos.

Administrator's Sale.

IN THE PROBATE COURT of the County of Santa Clara, State of California.

In the matter of the Estate of SEBASTIAN PERALTA, deceased.

Notice is hereby given that in pursuance of an order of the Probate Court of said County, made the second day of May, A. D. 1863, the undersigned, Administrator of said Estate, will sell at PUBLIC AUCTION, to the highest and best bidder, on **Wednesday, the 8th day of July, 1863**, at 12 o'clock M., at the Court House door, in said County, the following described Real Estate, to-wit: All that certain piece

SEBASTIAN PERALTA'S PROBATE AND THE SIMOND ADOBE. When Sebastian Peralta died in August 1859, he owned less than 300 acres of the original rancho. He had sold 2,500 acres to Frenchman Claude Simond in 1853 for $2,500. Simond built a one-room adobe, the third house on the rancho, and lived there with his family. In addition to the house, there were a barn and a sheep house to support the 800 sheep, 3 cows, 1 steer, 8 horses, and 3 wagons owned by Simond. Today the Simond adobe is incorporated into the entrance of a 1920s-era home on Quito Road, shown below. The administrator's sale notice shown above was issued by the probate court of Santa Clara County in 1863. It appeared in the *San Jose Mercury* in the month preceding the public auction of Peralta's estate on July 8, 1863. Jonathan Parr was the high bidder on all the land parcels, paying $1,620 for about 292 acres. Peralta's debts were settled, but little or nothing was left for his sole heir, an infant daughter named Rita. (Courtesy History San Jose and Seval Oz Ozveren.)

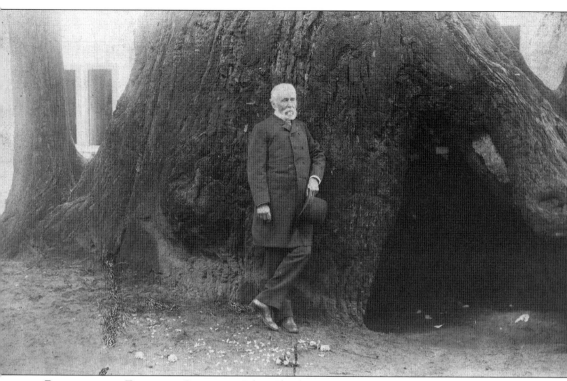

PERALTA AND FREMONT QUARREL. John Charles Fremont (1813–1890) led two "surveying" parties into Mexican California between 1844 and 1846. Understandably, the Mexicans did not trust Fremont, as his command consisted of 62 armed men, including frontiersman Kit Carson, who served as guide. While traveling to Monterey on February 20, 1846, Fremont and his men camped in the Santa Clara Valley. Sebastian Peralta rode into the camp, claiming that some of Fremont's horses had been stolen from his Los Gatos rancho. Fremont denied the allegation and ordered Peralta to leave the camp immediately. Peralta complained to Alcalde (or "Mayor") Pacheco of San Jose, who ordered Fremont to appear before him. Fremont's written response to Pacheco stated that Peralta had tried to obtain animals under false pretenses, and that "he should have been well satisfied to escape without a severe horse whipping." Fremont called Peralta a "straggling vagabond" and refused to appear before the alcalde. On July 9, 1846, the American flag was raised over Monterey. Fremont is pictured here in 1888 in front of the redwood tree near Santa Cruz that served as his "headquarters" in 1846.

KIT CARSON. Christopher "Kit" Carson (1809–1868), born in Missouri and apprenticed to a saddle maker at age 14, headed for Santa Fe at age 16. He was a trapper, a scout and guide, an Indian agent, and a military officer in the Civil War. John C. Fremont found Carson's skills invaluable on his Western expeditions, including his 1846 passage through the Los Gatos Gap. Jessie Benton Fremont called him unassuming and "sweet as a clear-cut winter morning is sweet." However, he waged a fierce campaign against the Navajo Indians, which ended in the Long Walk of the Navajo. (Courtesy Library of Congress.)

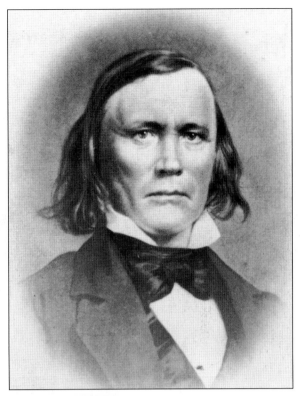

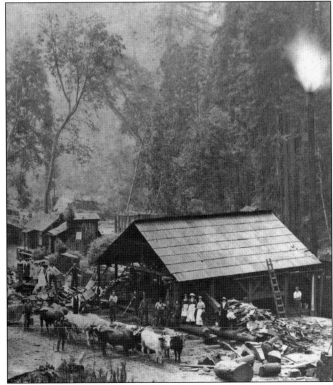

OPPORTUNITY. Many who settled in the Los Gatos area in the 1850s and 1860s first came west in search of gold. The virgin redwoods that covered the Santa Cruz Mountains offered another opportunity to harvest the great natural wealth of California. Oxen were used extensively, as shown in this 1880s view of the Loma Prieta Lumber Company mill near Olive Springs, 12 miles north of Santa Cruz.

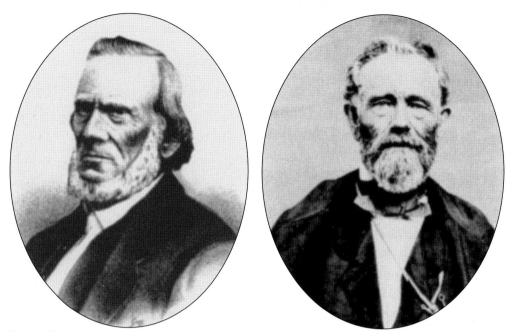

EARLY ENTREPRENEURS. Isaac Branham (1803–1887), seen here at the left, emigrated from Missouri to California in 1846 with his wife Amanda Bailey Branham (1813–1890) and their four children, traveling in two wagons drawn by oxen. In November 1847, Branham purchased half of the water and timber rights to the farm of Capt. Julian Hanks in order to construct the first sawmill and dam on Los Gatos Creek. The mill, located near Lexington, was sold in 1848 to Zachariah "Buffalo" Jones (right). Jones, who was born in Tennessee in 1807, had a booming voice, whether in song or sermon.

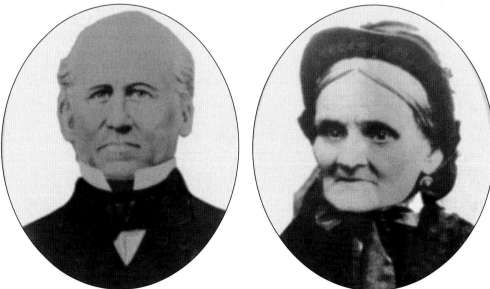

JAMES AND ANA MARIA FORBES. Scotsman James Alexander Forbes (1805–1881) arrived in Yerba Buena (San Francisco) around 1831. He married Ana Maria Galindo (c. 1816–1883) at Mission Santa Clara in 1834, and the couple had 12 children. In late 1852, Jose Hernandez sold Forbes approximately 2,000 acres of Los Gatos rancho land east of the creek.

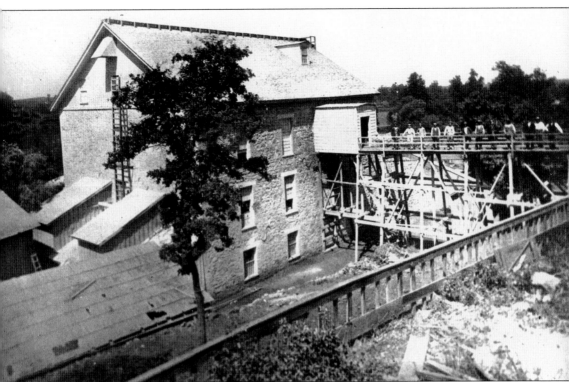

FORBES MILL. Forbes Mill was the first building in Los Gatos. Construction of the sandstone mill commenced in 1853, and production of Santa Rosa Brand flour began in 1855. A series of misfortunes caused Forbes to declare bankruptcy. The mill was purchased in 1866 by William H. Rogers, who was joined by investors Dr. William S. McMurtry, J. Y. McMillan, C. C. Hayward, and W. H. Rector (Theresa Lyndon's father). Finally, under the management of the Los Gatos Manufacturing Company, the mill became a successful enterprise. The last flour was produced in 1887, and the mill and its annex went on to other uses. Despite his failures, James Alexander Forbes was a remarkable man. As early as 1833, he served as chief of southern trappers for the Hudson's Bay Company. His time in California spanned from the days of the ranchos through the Gold Rush and into American statehood. He is most remembered for the establishment of his mill, the genesis of Los Gatos. Ironically, it was the flourishing orange trees planted near his flour mill that foreshadowed the mill's demise.

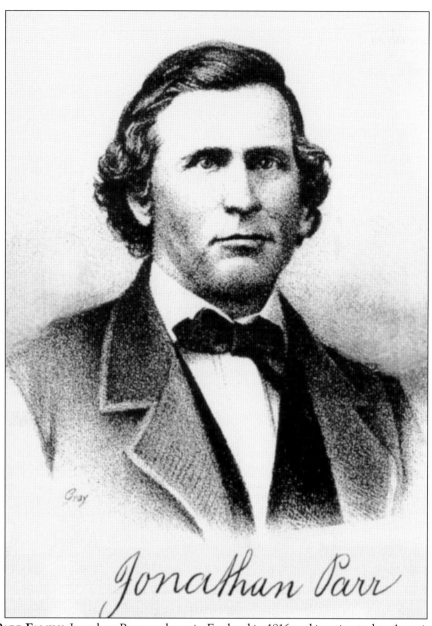

Jonathan Parr

THE PARR FAMILY. Jonathan Parr was born in England in 1816 and immigrated to America with his family in 1842. In 1846, the Parrs traveled in a caravan of 41 covered wagons across the Great Plains, headed for the Pacific Coast. Their arduous journey included instances of stampeding cattle, the killing of a man by Pawnee Indians, and a terrifying day when the wagon train was surrounded by 700 hostile natives. The immigrants survived, arriving in California in November 1846. In 1856, Jonathan Parr purchased more than 2,000 acres of the original Rancho Rinconada de los Gatos. He raised stock there until his death in 1867. Jonathan Parr and his wife, Eliza Jane Lowe Parr, had six children, each of whom inherited part of the land, which was described as "finely timbered, principally with majestic oaks." His other holdings included 230 head of cattle, 8 horses, and a cash reserve, the result of renting pasture land to his neighbors. Called "the fine old Englishman," Parr now has a street named in his honor.

MURDER AT THE COLEMAN HOUSE. In 1877, one of Jonathan and Eliza Parr's sons, 33-year-old Charles, was murdered on East Main Street in front of the Coleman House, the little two-story saloon and boardinghouse pictured at the far left. "The trouble was caused by three Spaniards riding by the side of Messrs. Parr and Johnson in such a way as to kick dust in their carriage," reported the *Santa Cruz Sentinel*. A fight erupted, and Bruno Uyoa was arrested for killing Parr with a ball from his pistol. (Courtesy of Chuck Bergtold.)

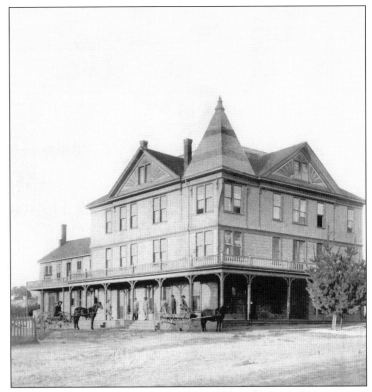

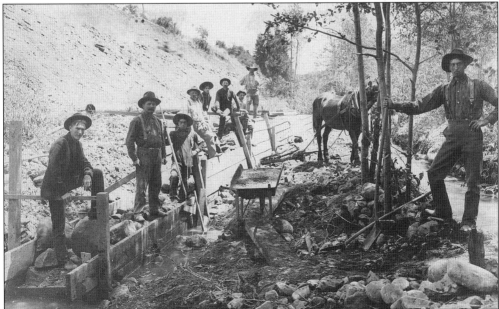

THE IMPORTANCE OF WATER. Beginning in the 1870s, the San Jose Water Company (founded in 1866) bought land and built impounding reservoirs and a flume in the Santa Cruz Mountains to capture runoff from mountain streams and to supplement the water supply available on the valley floor. Much of this activity centered around Los Gatos Creek, where a construction crew is seen in this undated photograph. (Courtesy Martin Shore.)

19

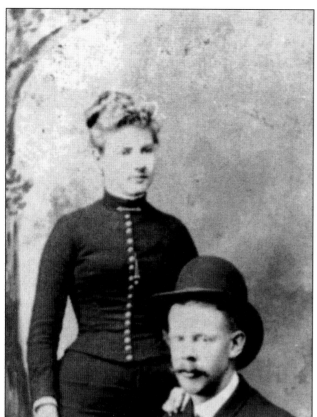

THE MCMURTRY FAMILY. In 1868, Dr. William S. McMurtry (1818–1904) and his wife, Olivia McMillan McMurtry, moved their family to Los Gatos and into the town's first residence, the old mill house on East Main Street. Two of their six children were Mary O. (1866–1953) and George (1865–1950). George worked at the old mill, went prospecting for Alaskan gold in 1898, and served as town treasurer for more than 40 years. Mary was a founding member of the History Club.

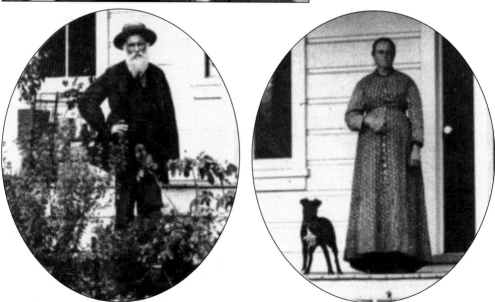

JAMES AND HELEN KENNEDY. James and Helen Kennedy were born in Scotland around 1805 and 1808, respectively. By 1859, they had settled at Lexington, becoming one of the first families to populate the little logging town. James was the gatekeeper on the Santa Cruz turnpike toll road until the road became public in 1878.

JOHN AND ANN JANE CILKER. John Cilker (1833–1909) came to the United States from Germany as an infant. He was orphaned at age eight. Ann Jane Lipsett, a native of County Donegal, Ireland, immigrated alone to Canada at age 18. The couple married in 1867, and that year they homesteaded 174 acres about two miles northeast of town. They called their home Aurora Farm. (Courtesy Bea Cilker Hubbard.)

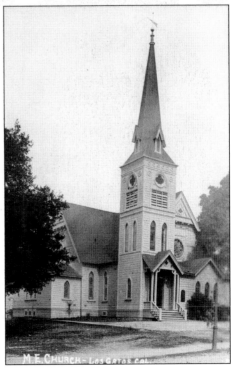

METHODIST EPISCOPAL CHURCH. The Methodist Episcopal Church was organized in Los Gatos in 1866, becoming the first formal religious body in town. "I held services under a live-oak tree just above the old stone mill as long as the weather would permit," stated William Bramwell Priddy, who was appointed preacher in 1867. By 1868, a small frame church had been built, followed by this structure in 1889.

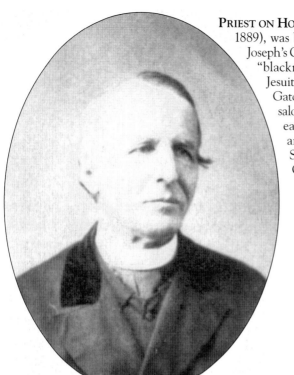

PRIEST ON HORSEBACK. Rev. Joseph Bixio, S. J. (1819–1889), was born in Genoa, Italy. He arrived at St. Joseph's Catholic Church in San Jose in 1857. The "blackrobe" (the Native American name for Jesuits) traveled 10 miles by horseback to Los Gatos to say mass in private homes or above a saloon. When the Civil War erupted, he went east and said mass for both Confederate and Union soldiers. He later returned to Santa Clara College. (Courtesy St. Mary's Catholic Church.)

CATHOLIC MISSION CHURCH, 1878–1912. Located at the southwest corner of North Santa Cruz and Bean Avenues, the Immaculate Conception church was attended by priests from Mission Santa Clara and, later, from the Sacred Heart Novitiate, established in 1888. (Courtesy St. Mary's Catholic Church.)

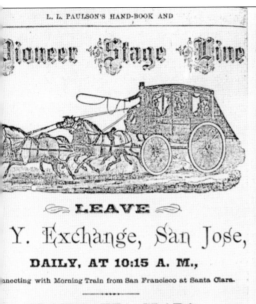

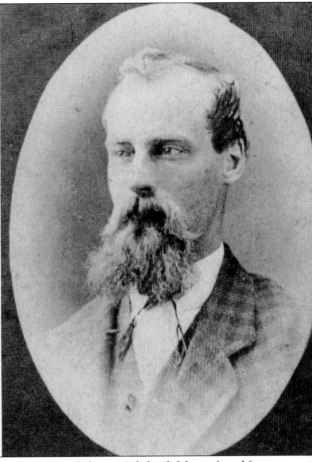

GEORGE LOUIS COLEGROVE (1843–1936). In 1850, George Colegrove's father left his wife and five small children in Illinois and went to California for gold. At age 20, George followed, driving the lead wagon of an emigrant train from Iowa. From 1869 to 1879, George drove Concord stagecoaches from San Jose to Los Gatos and then over narrow, twisting dirt roads on a wild ride to Santa Cruz. Along the way, he faced many challenges, including armed bandits and approaching logging wagons pulled by eight ponderous oxen. Colegrove met Alfred E. "Hog" Davis, president of the South Pacific Coast Railroad, in 1879. Davis told him, "The stage business will be done when the railroad tunnels are done." Colegrove worked on the railroad for 36 years, retiring in 1915. He was married to Margaret MacKenzie Colegrove and lived to be nearly 93 years old.

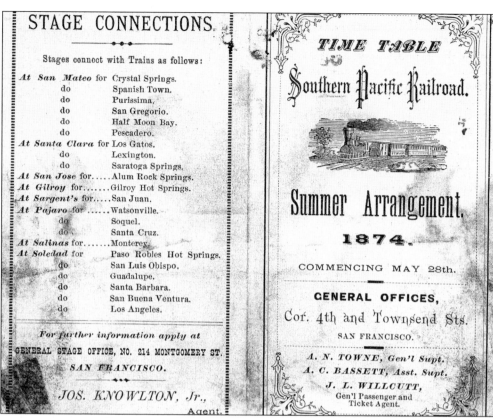

STAGECOACH SERVICE. This 1874 Southern Pacific timetable indicates that a person arriving by train in Santa Clara could then connect by stagecoach to Los Gatos. Train service into Los Gatos began in 1878. (Courtesy of Chuck Bergtold.)

THE VILLAGE SMITHY. Born in Yorkshire, England, in 1844, George Seanor arrived in the United States in 1855. He established a blacksmith shop, the Los Gatos Agricultural Works, in 1870 at age 26. His enterprises, located on East Main Street near Church Street, soon included a carriage shop, a shingle factory, and an opera house. He also owned a sawmill located south of town. He married Hester J. Daves in 1875, and daughter Georgia was born in 1878.

THE ORCHARDIST. James Birney Burrell (1840–1921), son of Lyman and Clarissa Burrell, the second American settlers in the Santa Cruz Mountains, was a pioneer orchardist. He traveled with his mother and sisters around Cape Horn on a 103-day trip to California between 1852 and 1853. At age 13, he helped his father build their "Mountain Home" near the summit. Later, he worked with his son, Frank L. Burrell, to build a machine that picked prunes mechanically and graded them by size. (Courtesy Frank Burrell.)

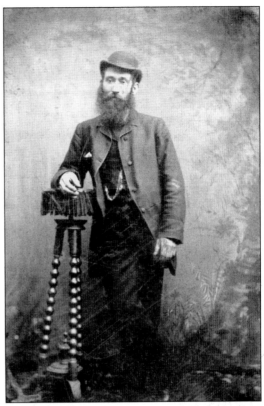

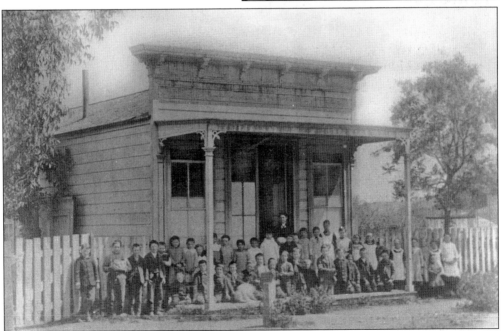

1875 SCHOOLHOUSE. This one-room, wood-slat school building was constructed on School Street (University Avenue) in the same area where University Avenue School, now the Old Town shopping center, was built in 1923.

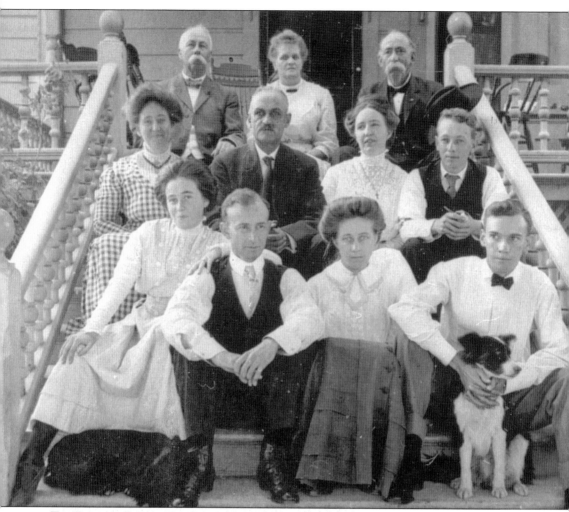

THE LYNDON FAMILY. Brothers John W. and James H. Lyndon were born in eastern Canada to an Irish immigrant father, Samuel Lyndon, and his wife, Polly. Samuel Lyndon, who could not read or write, worked as a day laborer to support his large family. In the 1850s, he moved them to Alburgh, Vermont, a farming district in the Lake Champlain Islands. Before they reached their teens, both John (c. 1836–1912) and James (1847–1912) were working on farms to earn their room and board. John (top right) arrived in Lexington in 1859 and worked as a clerk at Bernard Joseph's general store. Within two years he was a landowner. James (top left) enlisted in the Union Army as a teenager and survived the Battles of the Wilderness, Spottsylvania, and Cold Harbor. In 1869, he came to California, where he eventually set up a lumber business. James served as sheriff of Santa Clara County from 1894 to 1898. This photograph was taken at James Lyndon's home at 1 Broadway shortly before both brothers died within months of each other in 1912. James's second wife was Anna Murdock, seen here seated between the brothers. Members of the extended Lyndon family are seated in the first two rows.

Two

TOIL, TROUBLE, TRANSCENDENCE
1880–1899

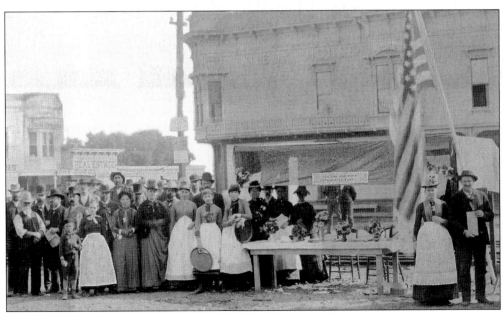

ELECTION DAY, 1883. According to notes penciled on this old photograph, Prohibition supporters were assembled in this election-day crowd at Oak Street (Montebello Way) and Main Street. Fred W. Crandall (1858–1941) stands with his wife Josephine at the right, holding a petition in support of a "dry" Los Gatos. (Courtesy Chuck Bergtold.)

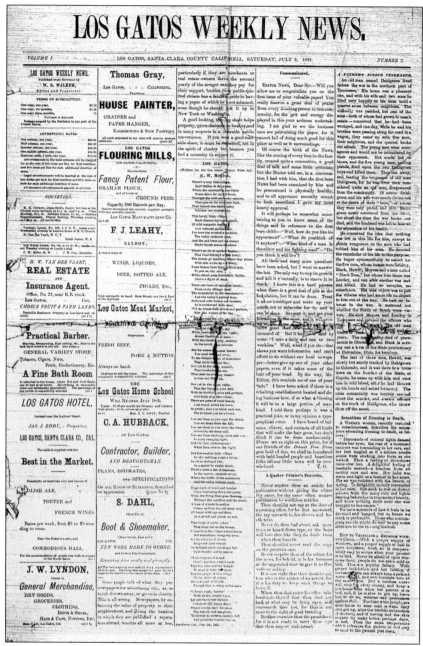

FIRST NEWSPAPER. William S. Walker founded the *Los Gatos Weekly News* on July 1, 1881. He was a Civil War veteran and a Republican who made his views known without apology. In 1885, the cantankerous publisher wrote, "We talk of days gone by when we were so happy and contented, when in reality were we to consult our old journals of everyday life, we would discover that we were just as miserable then as now." Fifty years later, George S. Walker remembered his father's early newspaper as an enterprise that owned "an old Washington hand press, a composing stone, about a hat full of type, and a keg of ink." He noted that, in 1881, "Los Gatos was a straggling village, with but one long road going through the town, and wagon drivers had to be careful, for at about every 100 yards large oak trees were growing in the center of the road."

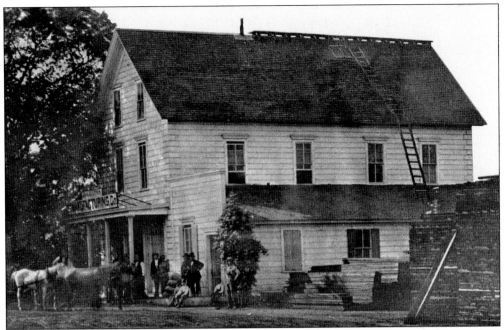

LOS GATOS MANUFACTURING COMPANY. The Los Gatos Manufacturing Company stood on Main Street, connected to the old mill below it by a footbridge. The business existed until 1887, when it merged with the Central Milling Company of San Jose and the machinery was sold.

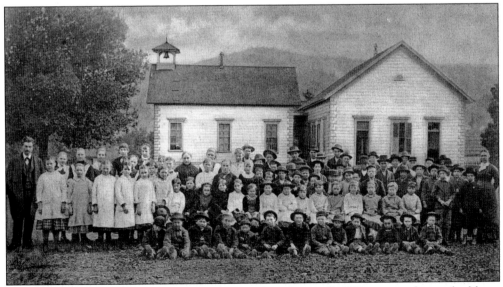

SCHOOL ADDITION, 1881. When school opened on August 8, 1881, a second room had been added to the original 1875 structure at a cost of $920. Ninety-eight children were enrolled. They are pictured here with their two teachers.

SOUTH PACIFIC COAST RAILROAD. When railroad service reached Los Gatos in 1878 and tracks were completed over the Santa Cruz Mountains in 1880, the economy of Los Gatos was greatly enhanced. Farmers shipped fruit from the mountains by rail. While most settlers would have preferred to farm the valley floor, much of that land was snarled in the litigation of the post-rancho era. (Courtesy Chuck Bergtold.)

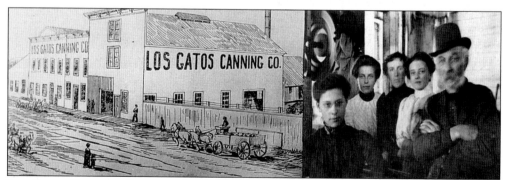

LOS GATOS CANNING COMPANY. In 1882, soon after the railroad began hauling tons of fruit out of the Santa Cruz Mountains, 14 stockholders built a cannery on land that stretched a full block westward from North Santa Cruz Avenue (approximately where the movie theater stands today) to Lyndon Avenue. Pictured are George H. Hooke (1859–1949), who purchased the company in 1894, and some of his employees. About one million cans of fruit were packed each year.

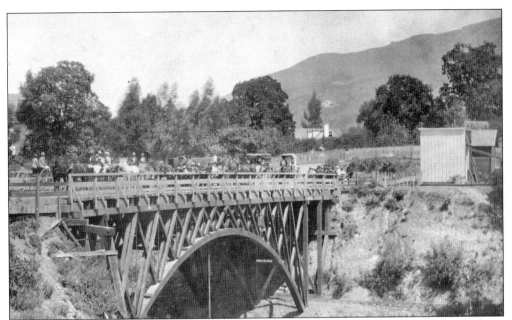

WOODEN BRIDGE, 1882. Crossing Los Gatos Creek was a challenge for early settlers. In winter, the undammed waters ran swift and full, washing away early bridges. An 1871 flood resulted in people being transported over the creek in swinging baskets. When this structure opened for horse-and-buggy traffic in May 1882, the town celebrated by gathering for this portrait. (Courtesy Farwell family.)

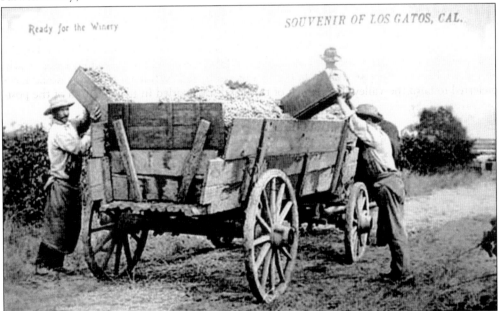

Ready for the Winery

SOUVENIR OF LOS GATOS, CAL.

PIONEER WINEMAKING. In 1885, the Los Gatos–Saratoga Winery was established between the two towns, and by 1900 it was producing up to 350,000 gallons a year. Prohibition resulted in the closure of the large wooden winery. The Los Gatos Cooperative Winery was built on land behind the current civic center in 1886. It produced over 300,000 gallons of wine per year in the late 1890s.

PRESBYTERIAN CHURCH. The bell in this church tower rang out in 1890 and again in 1891 to warn the town of fires. The church was established in 1881, holding its first meetings at Lyndon Hall on South Santa Cruz Avenue, an oblong building with a stage at one end. This building was completed in 1885 at a cost of $5,000.

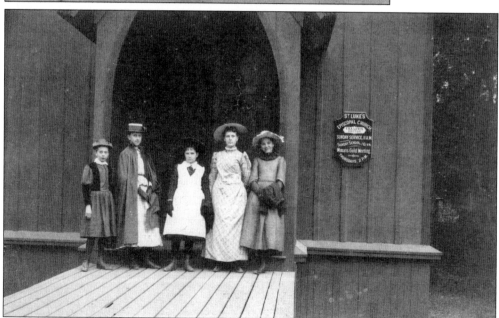

ST. LUKE'S EPISCOPAL CHURCH. This little wooden church was constructed in 1883 on land donated by Theresa Rector Lyndon, John Lyndon's first wife. The notice board indicates that F. B. A. Lewis is the rector. The church served until 1901, when it fell victim to fire. The probable identities of those pictured here in 1891 are, from left to right, Nina Robershotte, Edna Potter, Irma Lyndon, Clara Suydam, and Alice DeLong. (Courtesy Farwell family.)

FRANCISCA'S GIRLS. Alexandrina Filzon (left), probably the first-born child of Francisca Hernandez Filzon, was born in 1850 on the rancho. She married Bonifacio Pacheco in 1869 and bore six children. Her half sister, Hannah "Anna" Worden Hall Gonzalez, who was born in 1864, is pictured here around 1884. She was the daughter of Stephen J. Worden, a cooper (barrel maker) from Vermont who landed in Monterey while working on a whaling ship in 1844 and decided to stay. (Courtesy Melita Kelly.)

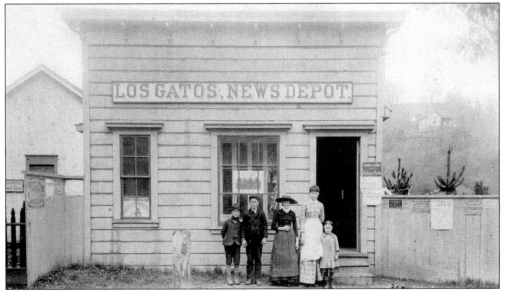

TOBIN'S NEWS DEPOT. John F. Tobin (1824–1889) was an Irish immigrant and a veteran of the Civil War, having served in Company F of the 26th Indiana Veteran Volunteers. He and his wife, Isabella Kirkpatrick Tobin (1838–1917), owned the town's first news depot, pictured here on East Main Street around 1885. Their children are, from left to right, Paul, Thomas, Mary (1878–1960), Helen (1869–1955), and Janet (1879–1946). (Courtesy Chuck Bergtold.)

FIRST BANK. The Bank of Los Gatos, incorporated on November 5, 1883, was located in this brick building on the south side of East Main Street, between Wilcox (College Avenue) and Seanor Street (Pageant Way). The organizers, a William Conklin and a Mr. Kirkland, are pictured here. The bank moved to the Theresa Block on May 1, 1891. This building was razed in 1925.

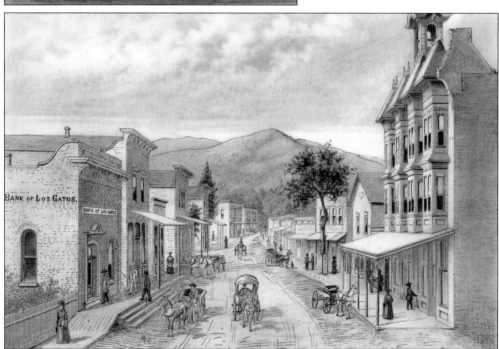

SKETCH OF EAST MAIN STREET, MID-1880S. This view looks west from Mill Street (Church Street) toward the wooden bridge. The "cartridge fire" of 1891 destroyed much of East Main Street, including the ornate Arlington Hotel at No. 47, shown at the right. Furniture was quickly removed as the flames approached, but the building, with its tower and turrets, collapsed within an hour.

PREMEDITATED MURDER. On the morning of March 12, 1883, Los Gatos awoke to news of grisly murders committed in the hills above Lexington, just south of town. William Peter Renowden and Archibald McIntyre had been viciously tortured and murdered, and their mountain cabin had been burned to the ground. Lloyd Leadbetter Majors (1837–1884), pictured here, masterminded the crimes. Majors was a Civil War veteran, wagon maker, lawyer, preacher, temperance advocate, owner of a Los Gatos saloon, and serial arsonist. He supplied his two young accomplices with pistols and with pincers to pull out Renowden's fingernails in case the victim refused to give up his gold. (Courtesy Santa Clara City Library.)

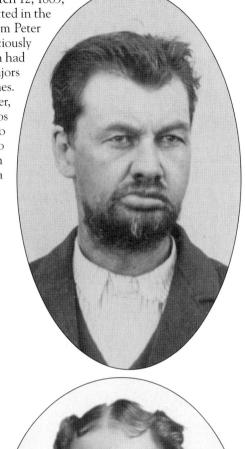

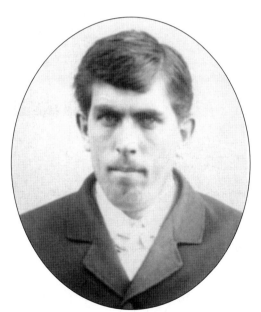

THE ACCOMPLICES. John Franklin Showers (1860–1899), pictured at the left, arrived in Los Gatos in 1876 with his widowed mother, Betsy Sackett Showers. The press referred to him as "a worthless blatherskite and lummox." He referred to himself as the "Bad Man from Bodie." He was rarely unarmed, and relished his own notoriety. Joseph Jewell (1854–1883), pictured at the right, was a 5-foot-4-inch, unassuming, well-spoken Englishman. New to town, he was a house painter by trade. (Courtesy Santa Clara City Library.)

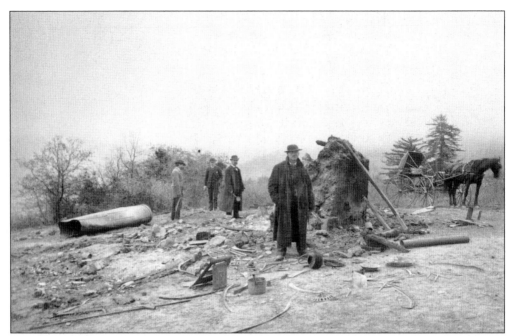

Murder Scene. A San Jose photographer traveled to Renowden's ranch off Bear Creek Road to record the aftermath of the "Lexington Murders." Only the chimney of the mountain cabin survived the fire that was set by Lloyd Majors to destroy the evidence against himself, Showers, and Jewel. The men pictured are unidentified but probably include Santa Clara County sheriff Benjamin Branham and Los Gatos constable Frank Reynolds. (Courtesy Santa Clara City Library.)

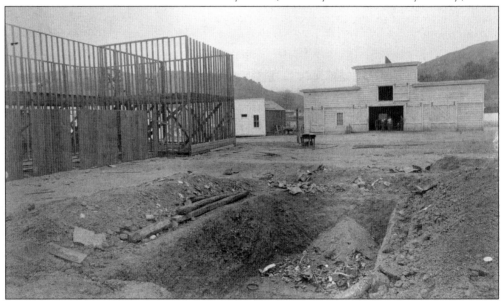

Digging for Bodies. When Majors was implicated in the Renowden and McIntyre bloodbath, angry citizens threatened to lynch him. They dug up the basement of his saloon, looking for additional murder victims, but found none. At left is Majors's unfinished hotel, which he hoped to finance with Renowden's gold. Across the street is John Daves's livery stable. (Courtesy Santa Clara City Library.)

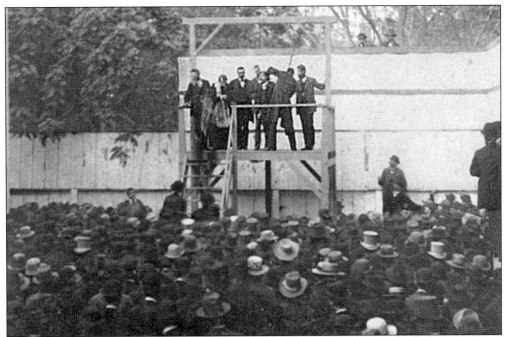

By Invitation Only. Within six months of the murders, Joseph Jewell was hanged in the yard of the Santa Clara County Jail on the same scaffold used to execute bandit Tiberico Vasquez. About 200 invited spectators showed up, including Mountain Charlie McKiernan and James and John Lyndon. When the noose was slipped over Jewell's head, he said "Put it on square—you have it twisted." It was adjusted, but it still took Jewell 13 minutes to die from strangulation. Majors was hanged in Oakland in 1884, and Showers was murdered by a fellow inmate at Folsom Prison in 1899. (Courtesy San Jose Public Library.)

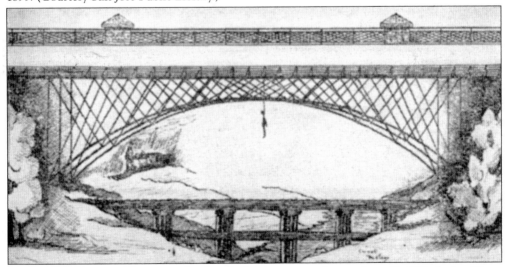

Hangman's Bridge. Three months after the Lexington murders, on June 17, 1883, the Los Gatos Vigilance Committee lynched Incarnation Garcia at the Main Street Bridge, an act witnessed by approximately 200 men, women, and children. A series of murders fueled the anger of residents, who feared Los Gatos was becoming known for its lawlessness. This drawing is from *Grandad's Pioneer Stories* by James Edwin Addicott, published in 1953.

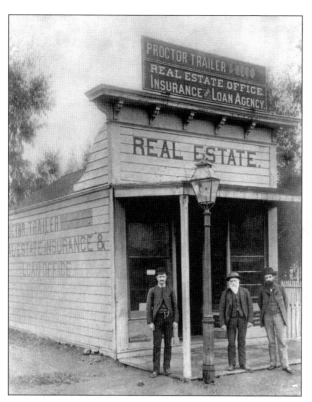

LOS GATOS REAL ESTATE. The office of Proctor and Trailer ("Reed" was dropped from the title) was constructed in 1884 on the north side of Main Street, adjoining the railroad tracks. In 1885, they were selling the Renowden estate for $25 to $50 an acre. This building fell victim to the 1901 fire. The First National Bank was built on this site in 1920. Civil War veteran William L. Lingley stands at the center with the business owners.

ALMOND GROVE. Exceptional fruit crops created a boom time in Santa Clara Valley in 1887. John W. Lyndon auctioned off the "Almond Grove Addition" on Saturday, September 7, after an excursion train from San Francisco arrived with 200 potential buyers. The sale lasted two hours and resulted in the purchase of 121 lots. The horse's ear in the lower right-hand corner indicates that the photographer captured this image while seated in his buggy.

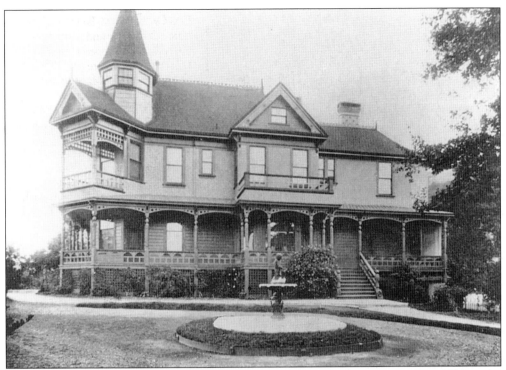

LYNDON HEIGHTS. John W. Lyndon built his grand home overlooking Los Gatos in 1886 on the site now occupied by Los Gatos Meadows. The three-story Victorian was constructed of heart redwood and had a rambling porch, 6 fireplaces, and 24 rooms. The house was painted a deep orange-red on the bottom and a soft yellow-green above. It was dismantled in 1969. (Courtesy Farwell family.)

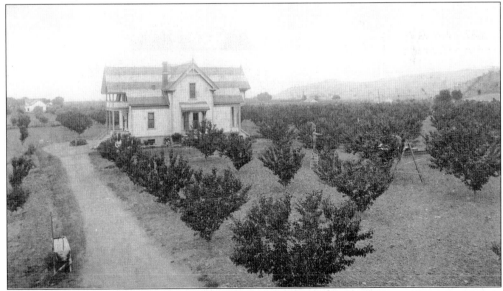

COUNTRY LIFE. Photography became available to most people in the 1880s, and home and family were the favorite subjects. This *c.* 1890 photograph by Swaney and Pierce Gallery shows a farm home near Los Gatos surrounded by fruit trees.

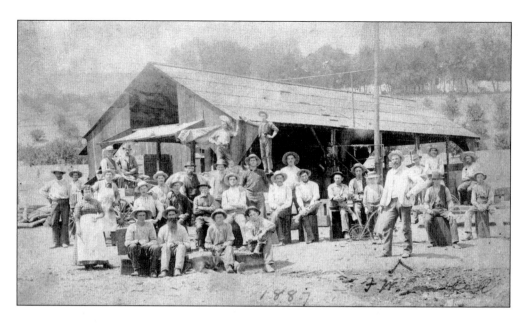

CRANDALL AND RICE. Fred W. Crandall and William Rice grew prunes and pears on 50 acres of land between Los Gatos and Saratoga. They operated the Big Orchard Drying Establishment, pictured above in 1887, an enterprise with 5,000 trays on the ground. Crandall is standing alone in the right foreground. The dryer burned down on July 17, 1901, and the fire consumed 431 tons of dried fruit. The bottom photograph, also dated 1887, shows the partners' warehouse, later sold to R. R. Bell. Fred Crandall is seated in the buggy, and William Rice is leaning on the wheel beside him. Rice, born in 1821, was married to Eliza Jane Campbell Rice. They had one living son in 1888, having lost eight children. At the far right is J. B. Waterman. (Courtesy Chuck Bergtold.)

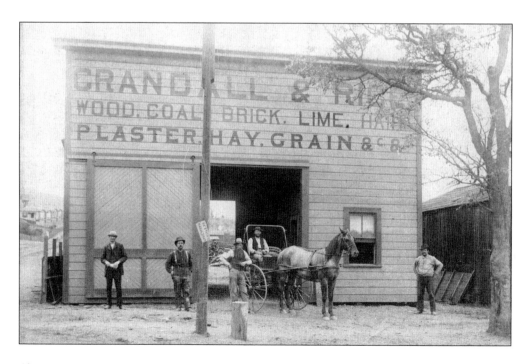

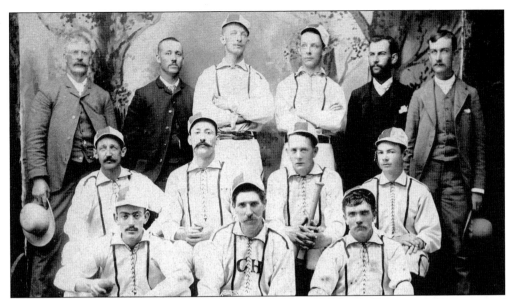

THE COULT AND HOLDEN NINE. Hundreds of locals attended baseball games in the summer of 1887 to support this team. The games were so exciting, reported the newspaper, that "the ladies could hardly keep from cheering." Pictured from left to right are the following: (first row) Lou Nieman (pitcher), L. A. Wilder (catcher), and Johnny Colbert (pitcher); (second row) George Suydam (center fielder), Zephyr Macabee (outfielder), Charlie Baker (first baseman), and Dick Shore (outfielder); (third row) C. W. Holden (manager), John Gaffney, Fred Suydam (third baseman), Charlie Suydam (second baseman), Zeph LeFevre, and Howard Coult (manager).

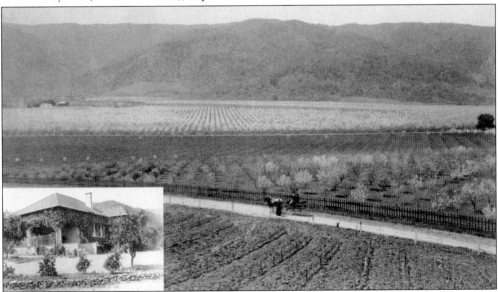

LARGEST PRUNE ORCHARD. The 680-acre Glen Una Orchard, pictured here on March 26, 1888, had 350 acres planted in prunes. Three smaller tracts of land between Los Gatos and Saratoga had been combined by George W. Hume to create the orchard. These included 450 acres formerly owned by Dr. George Warren Handy, father of Una (born in 1872), for whom the orchard was named. This was a model farm, with a private waterworks and an electric-light plant. (Courtesy Chuck Bergtold.)

FRANK W. KNOWLES, M. D. (1858–1936). Frank Knowles graduated from Chicago's Rush Medical College in 1883 and headed straight to Los Gatos to set up practice. He was a "horse and buggy doctor" who later had a well-appointed office over Green's Pharmacy. In 1896, he married Sabra Ann Roberts (1860–1913), daughter of pioneers John J. and Martha Roberts. His second wife was Olive Warren (1880–1942), by whom he had one child, Frank W. Knowles Jr. Dr. Knowles owned 42 acres of orchards on San Jose Avenue.

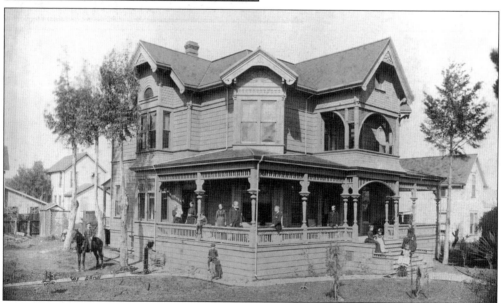

GOBER AND BEAN RESIDENCE. Inventor John Bean (1821–1909) and his son-in-law Dr. Robert P. Gober (1859–1943) built this home at the corner of North Santa Cruz and Bean Avenues in 1889. All of the rooms and fixtures on the north side were duplicated on the south side to accommodate the two families. Dr. Gober had a speaking tube installed beside his bed so that he could talk to patients who knocked on his door at night. The home was demolished in 1938. (Courtesy Stan Chinchen.)

QUARTET. This nicely executed cabinet photograph was produced by the Swaney and Pierce Gallery, which was located on Main Street from about 1888 to 1890. Homer A. Swaney (1855–1941), seated at the left, came to Los Gatos from Ohio around 1881, when he was employed as a mail clerk. N. L. Buck is seated at the right, and Mr. Pierce is sitting on the low stool. The man standing is unidentified.

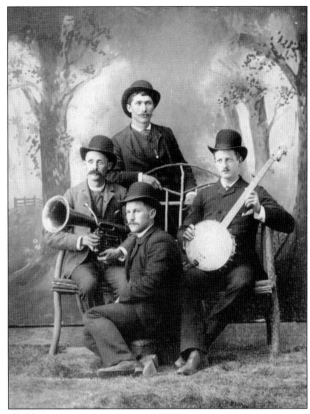

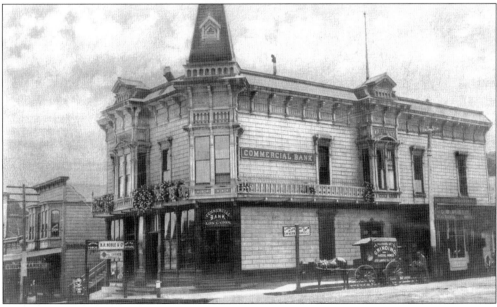

COMMERCIAL BANK. The Wilcox Block housed the Commercial Bank on the southwest corner of West Main Street and Oak Street (later known as Front Street and then as Montebello Way) from its establishment in 1889 until the building was destroyed by fire in 1901. Built by Harvey Wilcox in 1885, the block was valued at $20,000. It was replaced by the Rankin Block in 1904.

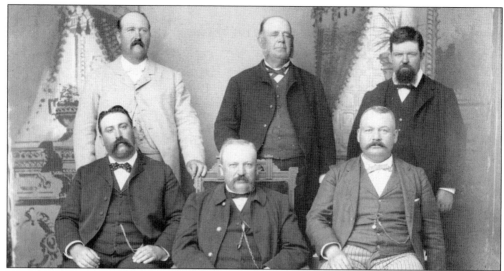

THE SOLID SIX, 1889. Pictured from left to right are the following: (front row) John C. Miles, rancher and banker Ebenezer Farley, and orchardist and attorney Charles F. Wilcox; (second row) Gilbert Turner of the Bank of Los Gatos, orchardist Abraham Rose, and laborer Thomas von Carnop. John C. Miles and Samuel Edelen subdivided the vineyard north of the grammar school in 1888. Charles F. Wilcox committed suicide in 1897 by swallowing carbolic acid, a substance commonly used for spraying fruit trees.

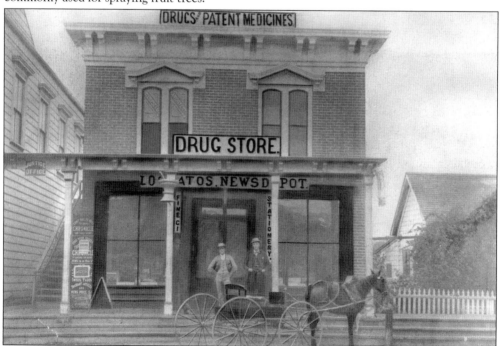

1880s DRUGSTORE AND NEWS DEPOT. This building was located at 5 North Santa Cruz Avenue. Patent medicines reached their zenith in the late 19th century, making colorful and exotic claims for relief of all sorts of suffering. The Ancient Order of United Workmen building, at the left, was constructed in 1881. It was moved to West Main Street in 1894 in preparation for the construction of the Hofstra Block.

THERESA BLOCK. John Lyndon, seen here standing at the far right, built the Theresa Block in 1891 at the northeast corner of Main Street and Santa Cruz Avenue. He named it for his wife Theresa, who died in 1888. Lyndon married Marian Carson in 1892. The building housed the homegrown Bank of Los Gatos for many years. It was demolished in 1931.

HUETER'S HAY. Gustave Hueter (1836–1905), a San Francisco paint manufacturer, retired to his 400-acre Mountain Springs Ranch around 1890. This rare photograph shows his wheat field, which was located on land that is now Redwood Estates. Tragedy stuck in July 1905, when Hueter, 68, was shot and killed by Kate U. Hueter, his 33-year-old third wife. Kate claimed self-defense, and a grand jury agreed. Newspapers reported that she had been involved for some time past in an "intrigue" with a Los Gatos physician. (Courtesy Linda Ward.)

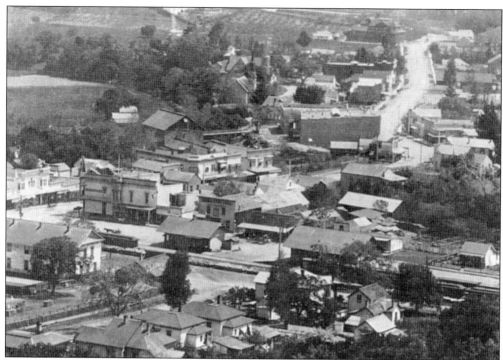

GEM CITY. Los Gatos was incorporated in August 1887 in order to establish the town boundaries, improve the roads and sidewalks, and manage sewage. This photograph was taken after the construction of the Beckwith Block c. 1893 but before the fire of 1901, which leveled everything from the bridge to the railroad tracks.

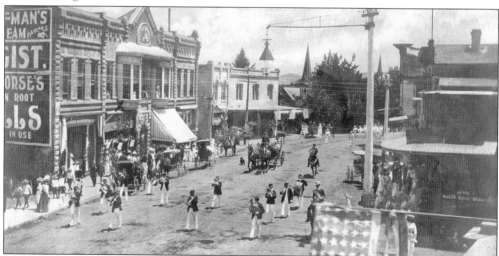

BUILT TO LAST. After the 1891 fire destroyed the original McMurtry and McMillan wooden store on East Main Street, civil engineer Nathan E. Beckwith constructed the brick building at the left. This photograph was taken after June 24, 1896, when electric street lights were first turned on in town. At 8:00 p.m. the streets were thronged with people, and the brass band was on the veranda of the Los Gatos Hotel. The *Los Gatos Mail* reported on June 30, 1896, that as the lights came on, the Gem City "shone with a luster and brilliancy that brought expressions of delight from every beholder."

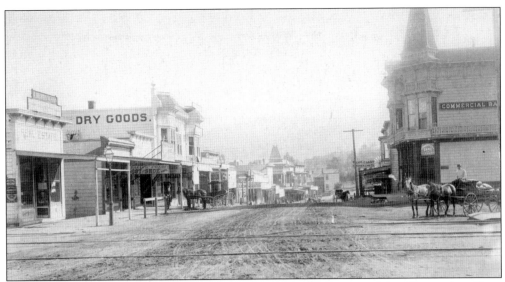

LIFE IN LOS GATOS, C. 1895. In the top photograph, looking west on Main Street, the village appears sleepy. On the south side of the street, the Union Market and the Pacific Coast Photograph Company are visible, while on the north side the "Dry Goods" sign designates the Parr Block at 140 West Main Street. Under magnification, as shown below, one of the town's numerous saloons appears. This all-male sanctuary, which probably featured a makeshift bar and wooden chairs, provided a place where men could congregate, gamble, and drink 5¢ beer. Saloons sported names such as the Buffalo, the Hunter, Lundy's, Pearson's, the Arcade, the Boss, E. J. Leahy Saloon, the Coleman Saloon and Boarding House, and Matt Doolen's, which was owned by the third Los Gatos fire chief.

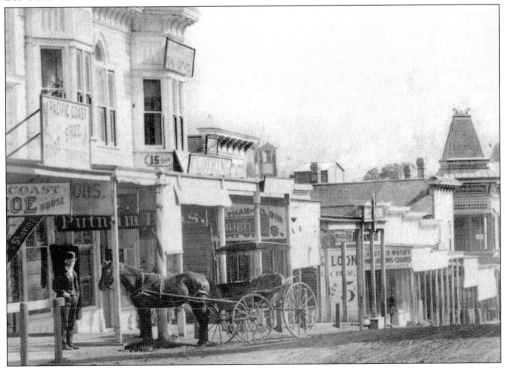

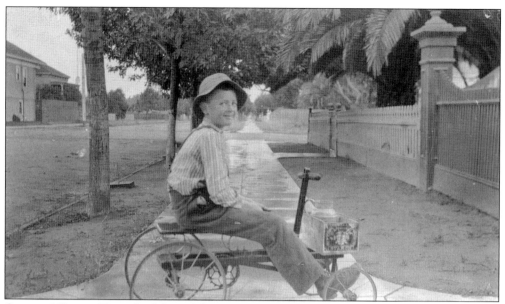

CRUISIN' DOWN TAIT. Paul Simon (1884–1912) grew up on Tait Avenue, the oldest son of Southern Pacific engineer Peter Simon and his wife, Susan. Paul is pictured here around 1895 on his "Irish Mail" machine. A notable embellishment on Paul's car is the wooden box with a "starch" label. Paul died at age 28.

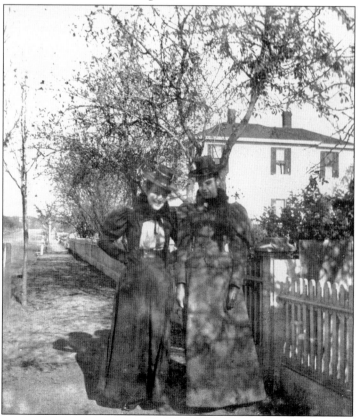

WINTER WALKING SUITS. Two fashionably attired cousins stroll the byways of Los Gatos in the late 1890s, despite the lack of sidewalks. Blanche Starkweather (left) was born in 1874 in Iowa. A teacher who lived on Broadway, Starkweather married Harry S. Beckwith, a grocer, in 1896. Pearl M. Blank, born in 1884 in Iowa, was the daughter of Moses F. Blank (1855–1932), who served as the constable of Redwood township from 1894 to 1898, and Louise Sporleder (1861–1950). She lived with her family on Edelen Avenue and worked as a music teacher. Blank later married Edward Baker, a mining engineer.

SUSAN STOCKER SIMON (1853–1921).
Susan Stocker Simon was the daughter
of James T. Stocker (1824–1892), who
came to Monterey in 1842 and helped
hoist the American flag there in 1846.
Her mother, Elizabeth, came around
Cape Horn in 1850. Susan married
Peter Simon in 1876, and they later
purchased a lot to build their home at
125 Tait Avenue, where she is pictured
with one of her daughters.

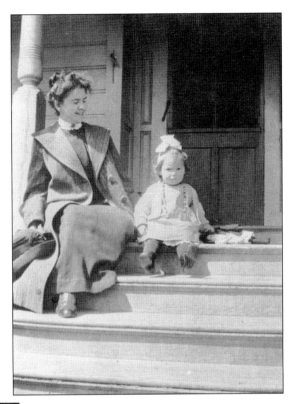

ANN JANE LIPSETT CILKER. Ann Jane Lipsett,
born in 1847, married John Cilker in British
Columbia. The couple planted orchards on
their Los Gatos land. Their children, born
between 1869 and 1886, were Martha, Jennie,
Ada, Archie, John, Robert, William, Frank
and Florence. The Cilkers lost two baby
boys: George at seven months in 1875 and
Montgomery at one year in 1877. Ann Cilker
is pictured here in the 1890s. (Courtesy Bea
Cilker Hubbard.)

MAIN STREET BARBER. Zephyr Albert Macabee (1857–1940) was born in New York, one of eight children. His Canadian-born parents, Edward and Matilda, came to Los Gatos in 1883 and purchased the Coleman Saloon and Boarding House. Zephyr set up a barbershop on East Main Street, where he is pictured around 1895. Zephyr's son Raymond (1895–1984) is at the right. (Courtesy Sunshine Tomlinson and Joyce Macabee Ridgely.)

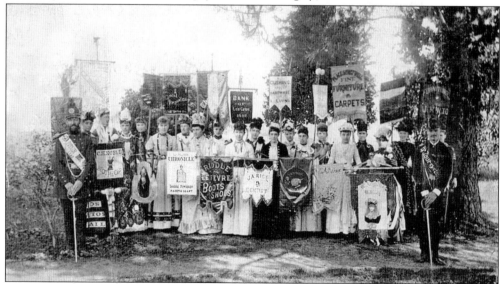

MERCHANT BANNERS. A board of trade was organized in Los Gatos in 1895 for the express purpose of "advancing the prosperity of every man in town." The businesses represented are White House Dry Goods, C. H. Noble Apothecary, the *Los Gatos Mail*, the *Los Gatos Chronicle*, Riddle and LeFevre Boots and Shoes, J. A. Rice Dentistry, Mrs. C. F. Arguella's Millinery and Dressmaking, the Bank of Los Gatos, Cushing Hardware, and Place and Fretwell Fine Furniture. (Courtesy *Los Gatos Weekly Times*.)

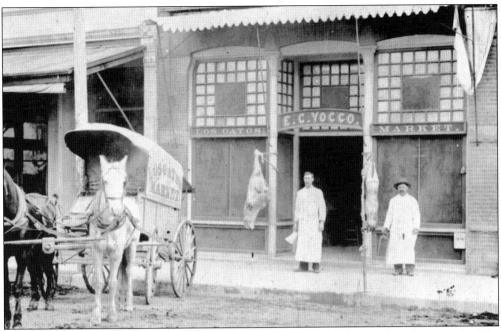

YOCCO'S LOS GATOS MARKET. Edward Clement Yocco (1857–1901) moved to Los Gatos in 1881 and worked at the Los Gatos Meat Market on East Main Street, a business established in 1870 by the Goldsworthy brothers. He purchased the business in 1889, and he moved it to a shop on North Santa Cruz Avenue in June 1891. The two employees are Bat Garratt (left) and Pete Roumaset.

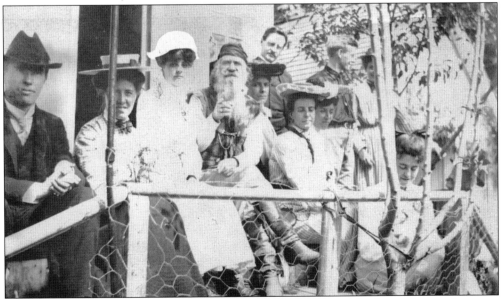

JOAQUIN MILLER'S PORCH. Joaquin Miller (1839–1913), the "Poet of the Sierras," sits at the center of this photograph. He is surrounded by admirers, including Peter and Susan Simon of Los Gatos, seen at the left. Miller (his given name was Cincinnatus) was a colorful and unconventional man. His poem "Columbus" was memorized and recited by legions of schoolchildren. He recited the work himself at the 1897 dedication of Bunker Hill Park in Los Gatos. This photograph was taken at his Oakland Hills home around 1895.

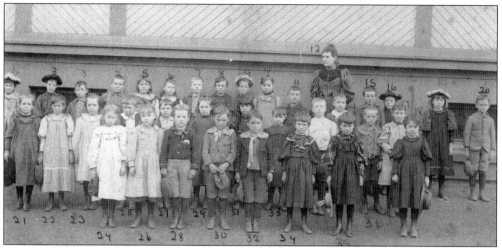

Miss Van Meter. On March 10, 1896, Louise Van Meter, seen here at the rear, lined up her class in orderly rows beside the Central School for this portrait. Pictured from left to right are the following: (first row) Vera Cooke, Maggie Eubanks, George Collins, Hewitt Bond, Stewart Bond, Myra Crosby, Muriel Killam, and Ethel Evans; (second row) unidentified, May Brown, Bessie Covell, Harry Wilder, Roy Seymore, Maggie Lemmon, Ethel Blank, unidentified, Carl Wren, Jim Langford, and Hazel Langford; (third row) Ella Olave, Irene Hoeber, Paul Crummey, Bennie Olave, Inez Pope, Josie Brown, Gus Hensley, Ray Robinson, Beatrice Penny, Sina Sorenson, George Place, Leland Walker, Nathan Clinkenbeard, two unidentified people, and Frank Bell.

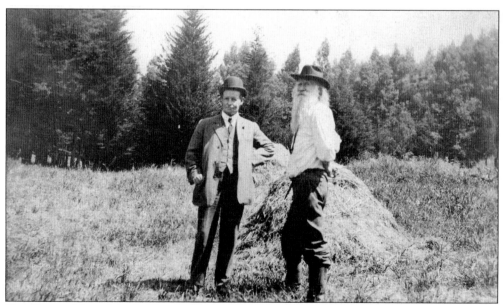

Two Poets. Henry Meade Blande (1863–1931), seen here at the left, served as principal of Los Gatos Central School for two terms, from 1887 to 1889. An eminent educator, he was appointed California Poet Laureate in 1929. While at Los Gatos, he instituted a "post-graduate" course—in effect, the first high school classes in town. Joaquin Miller's poetry, or perhaps Miller himself (pictured at right), was especially appreciated in Europe. (Courtesy Santa Clara City Library.)

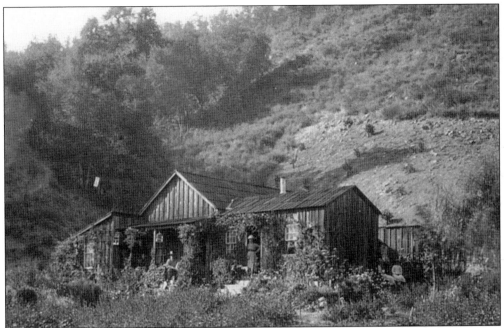

MONTE PARAISO RANCHO. Writer Josephine McCrackin's literary salon near the summit of the Santa Cruz Mountains was active from 1880 to 1899, when the buildings burned down. During the years it operated, Monte Paraiso was visited by most of the important American writers of the day, including Ambrose Bierce, Bret Harte, and Mark Twain. (Courtesy Bancroft Library, University of California, Berkeley.)

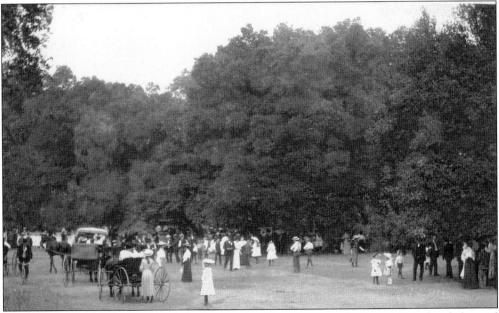

SUNDAY IN THE PARK. For more than 50 years, Los Gatos was proud of its municipal park, located at the foot of Park Avenue just south of the Main Street Bridge. Land was donated by William C. Shore, J. D. Farwell, and others. Every point in the town's progress was celebrated near the thick groves of sycamore and oak trees that lined the creek. Highway 17 came through the park in 1954.

53

SHERIFF LYNDON. The mass murder of the McGlincy family of Campbell took place on May 26, 1896. James C. Dunham rode his bicycle to the McGlincy ranch that evening to see his estranged wife Hattie and their baby son. Before he left, he mutilated and murdered six people, leaving only his son alive. In this Andrew P. Hill photograph, Sheriff Ballou of San Luis Obispo, left, and Sheriff James Lyndon are about to go after Dunham with bloodhounds and a 100-man posse. Dunham was never found.

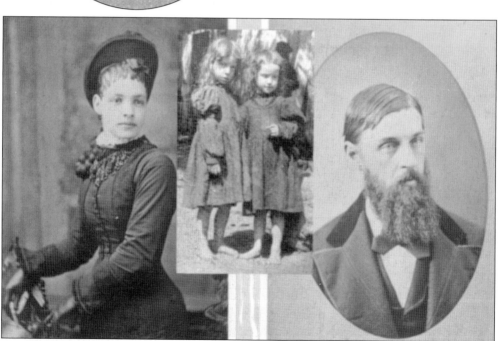

VILLAGE SHOEMAKER. Wells McGrady (right), a Civil War veteran, was born in Ohio in 1845, and by age 15 he was working as a shoemaker. Wells married July B. Weber (1858–1907), born in Louisiana, and the couple had five children, including twins, Geraldine and Genevieve, pictured here. The family moved to Los Gatos in 1898, where McGrady produced beautiful soft-turned soles and gaiters. (Courtesy Betty Jones Ermert and Geraldine Jones Peters.)

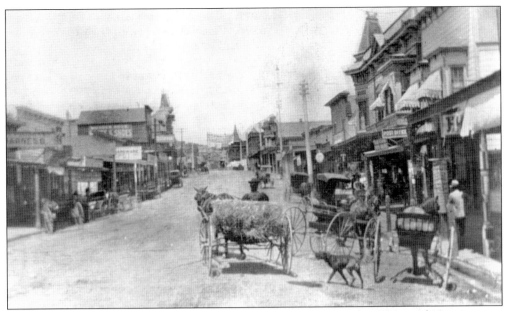

EAST MAIN SNAPSHOT. This photograph was taken around 1900, when the new $1 box cameras were all the rage. The hay cart is heading west toward the turret of the Hofstra Block (now the La Canada Building). Businesses pictured include a harness maker, a blacksmith, carpenters, a cigar manufacturer, a shoemaker, and Mrs. Sarah A. Surface's furnished rooms for rent, located near the post office at the right.

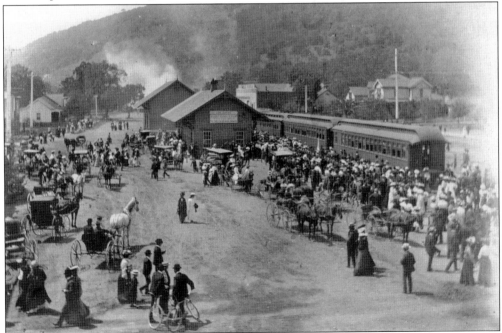

RAILROAD TOWN. From March 1878—when the railroad formally arrived in town—until the "Pulling of the Spike" ceremony on January 24, 1959, the culture and economy of Los Gatos were shaped by its railroad. Hauling fruit and redwood out of the mountains was profitable, and passengers enjoyed the magical trip by rail to the coast. (Courtesy Chuck Bergtold.)

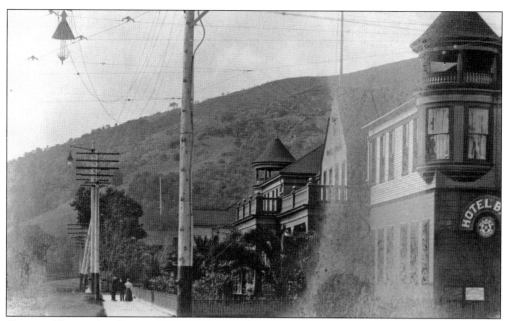

GRANDE DAME. A gala opening party for Hotel Lyndon was held on June 1, 1899, one year after a fire destroyed its predecessor on the corner of Santa Cruz Road and Hotel Street (West Main Street). "Just opened in Los Gatos!" said an advertisement in the *San Jose Daily Mercury*. "Four hundred incandescent lights, all modern conveniences, large public rooms, no inside bedrooms, all newly and elegantly furnished; first-class table. Special rates for summer boarders."

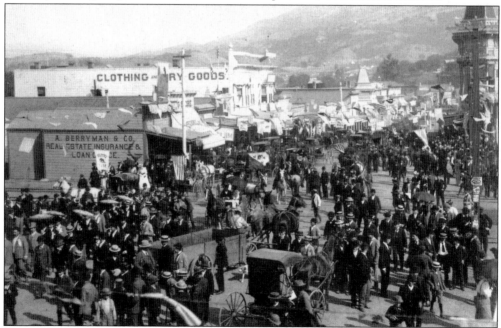

PROSPERITY. By the end of the 19th century, the frontier had been mostly tamed, and free land was no longer available. While Los Gatans still exhibited rugged individualism and a strong work ethic, key elements of the culture—especially industrialization and new inventions—were beginning to fuel a period of dramatic change.

Three

NO SMALL IDEAS
1900–1920

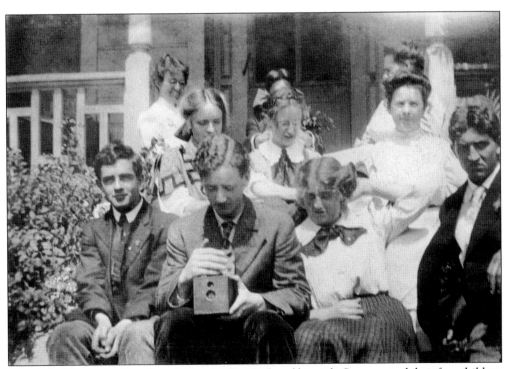

HERE'S LOOKING AT YOU. Peter Simon (1853–1916) and his wife, Susan, raised their four children at 125 Tait Avenue. They are pictured here around 1904, sitting on the front steps of their home. Peter appears at the lower right; above him is his daughter Erma, and above her is Susan. At the lower left are Cecil S. Simon (1889–1944) and Paul Simon, holding a new box camera.

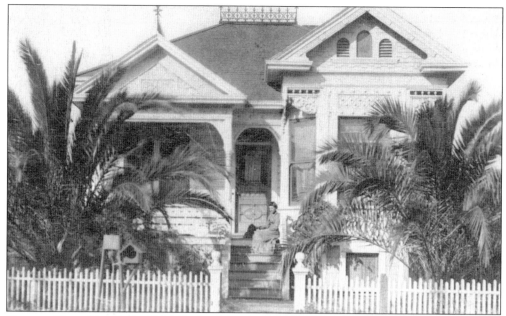

GOPHER TRAP HOUSE. In 1900, Zephyr Macabee patented the gopher trap he invented in the basement of this house on Market Street, now designated as 110 Loma Alta Avenue. More than 100 years later, the traps are still being manufactured at the same location. Elizabeth Gansburger Macabee, born about 1862, emigrated from Germany in 1866. She is seen here sitting on the porch with her little dog.

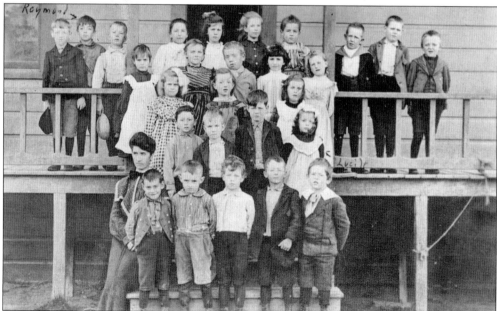

MARKET STREET SCHOOL. The Macabee children attended school on the street where they grew up. Raymond (top row, second from left) worked all of his life making gopher traps. His sister Lucile (second row, far right) was a music teacher and pianist who also spent some time in the trap business. This photograph was taken around 1903, before the youngest child, Roma, was in school. (Courtesy Sunshine Tomlinson.)

HERNANDEZ LEGACY. Melvel Medardo Hall (1885–1952) was the great-grandson of Jose Maria Hernandez, one of the grantees of the Rancho Rinconada de los Gatos. "Mel" is pictured here in 1900, when he had just gone to work for the San Jose Post Office as a special delivery boy. Two years later, at age 17, he started his Evergreen mail route, delivering by horse and buggy. (Courtesy Melita Kelly.)

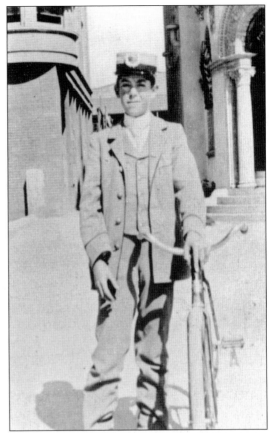

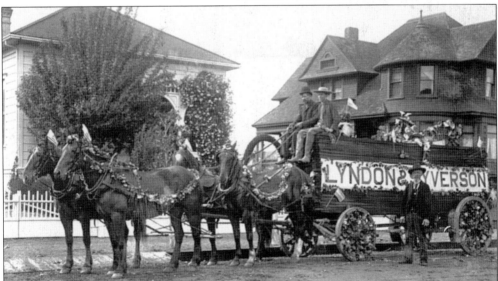

LYNDON AND SYVERSON LUMBER COMPANY. Samuel Syverson (1839–1907) was a Norwegian immigrant who came to Los Gatos in 1872. He lived on Edelan Avenue with his wife, Jennie. He is shown here in the first decade of the 1900s standing beside what is probably a July Fourth parade entry sponsored by the company he co-owned with James H. Lyndon.

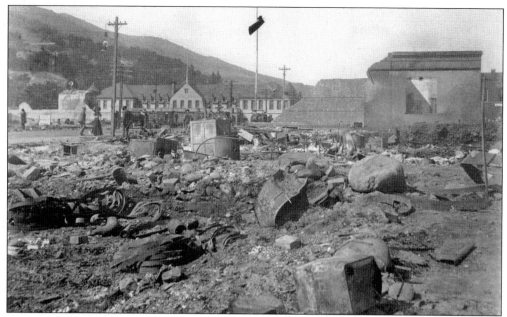

DISASTER! At about 3:00 a.m. on October 13, 1901, the fire bell rang and called residents to a horrifying scene. Fire, the terrible red monster, had possession of the town. Wind spread the flames, the fire hose burned, and an open hydrant could not be reached, leaving only buckets and a small stream of water with which to fight. The Lyndon Hotel, destroyed by fire in 1898, was saved this time by the railroad tracks.

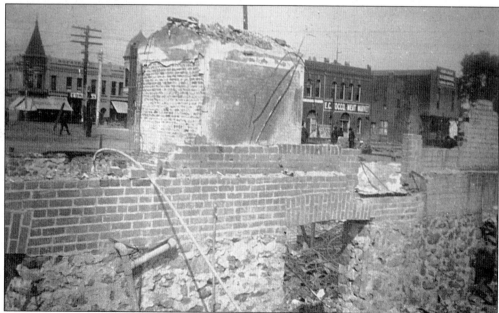

AFTERMATH. Firefighters were forced to vacate one position after another. Within two hours, the Gem City was a picture of desolation. The loss was estimated at $155,000. The vault of the Commercial Bank, pictured here, survived, as did the schoolhouse and bridge. But the Parr Block, the Gibson Block, and the Episcopal Church crackled, crumbled, and fell, along with more than 50 other buildings, including two or three barns.

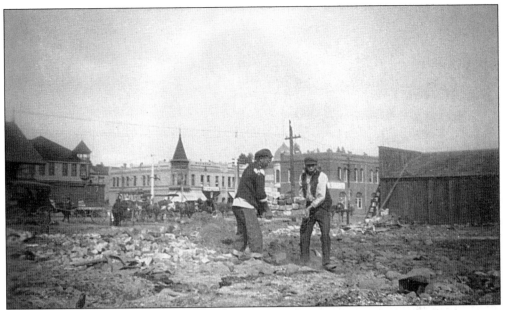

RECOVERY. Cleanup and reconstruction started almost immediately. Some saw the fire as an opportunity to widen Main Street and impose a single style of architecture for reconstruction in the burned area, located between the bridge and the railroad tracks.

FIRE BELL DOWN. The town's 2,220-pound fire bell fell 65 feet in the fire, sustaining several cracks. The bell had been hoisted by Hume's span of gray horses to the top of a wooden tower on October 15, 1899. During the conflagration, the tower stood for a half-hour, sheeted with fire, but finally collapsed with a deafening crash. A month later, the bell had been installed on a new tower at the same Lundy Lane location, and it stayed in place until 1947, when it was sold and made a strange odyssey to a Lodi chicken restaurant. The bell was gifted back to Los Gatos by Andy Kinyon in 1987 and now sits in front of the art museum.

SCHOOL PLAY. This photograph was taken by Gem City Studio of Los Gatos. The location is probably the Central School, the Victorian-era predecessor of University Avenue School. The boy dressed as a Native American is unidentified. The other boys are Cecil S. Simon (left) and his brother Paul.

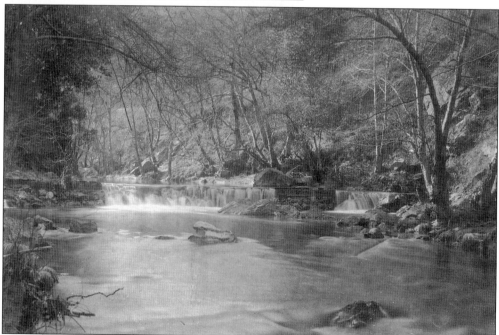

THE BOOGANG. "No girls allowed" was the rule at the old swimming hole south of town. The Boogang, whose moniker is unexplained, created memories for generations of boys. The pool was formed when the San Jose Water Company built a dam across the creek. Some boys switched their allegiance to the municipal plunge when it opened in 1927. (Courtesy Carl Ambrosini.)

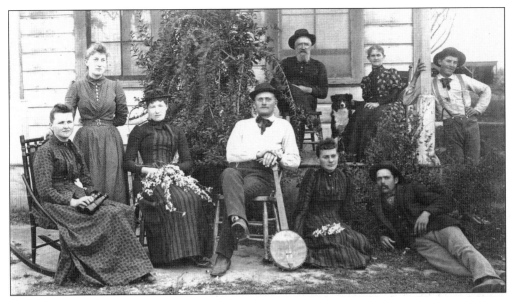

PIONEER HOME. Mary Rand Crooks Knowles (1822–1901) was a widow when she arrived in Los Gatos in 1883, accompanied by three of her children. Knowles purchased the Greeley House next to the Methodist church, pictured here, which had served as a way station for teamsters. When her son Dr. Frank Knowles joined them, he set up practice in one of the front rooms. The extended Knowles family is pictured here around 1900.

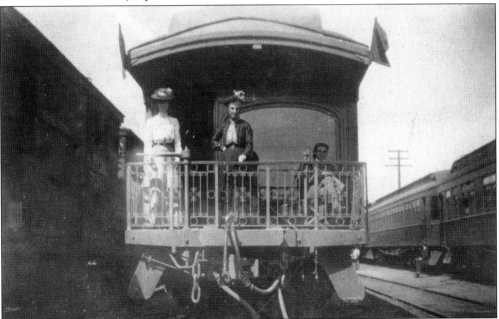

LOS GATOS YARD. These passengers are traveling in style to Santa Cruz aboard an observation car on narrow-gauge rails. This photograph was taken before the 1906 earthquake. Accidents on the railroad were fairly frequent. In March 1906, engineer Peter Simon had the unfortunate experience of backing his engine toward the roundhouse when Lewis Schilling, age 72, stepped into his path. Schilling's body was "severed in twain," according to the March 25, 1906, *Sunday Mercury Herald.*

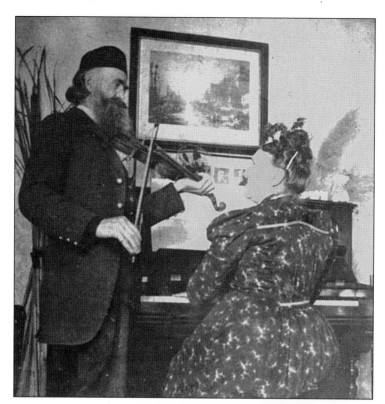

DUET. S. Harris Herring was born in 1836, and he came to California from Maine in 1856. In 1861, he joined the First California Cavalry and served in the Civil War. At one point during his service, he escorted 105 Confederate prisoners to Fort Clark, Texas. In 1895, he and his wife, Dr. L'Aimee P. J. Herring (1834–1929), settled in Los Gatos. They are pictured here in 1902. She practiced medicine in Santa Cruz in the first decades of California statehood.

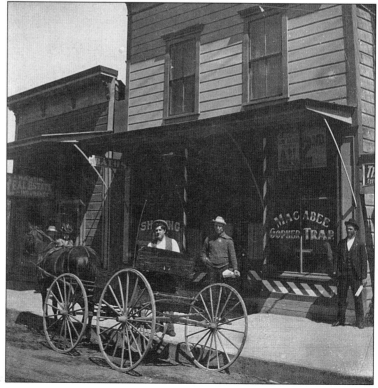

ONE-STOP SHOPPING. Zephyr Macabee's business establishment on East Main Street, seen here in the first decade of the 1900s, shows him in transition from barbering to making gopher traps. In an interview in the July 30, 1931, *Los Gatos Mail News*, Macabee described himself as a farmer's son, which meant "a lot of hard work, doing without, and getting along on nothing." (Courtesy Sunshine Tomlinson.)

ST. LUKE'S EPISCOPAL CHURCH AND THE TOWN FIRE BELL. When the great fire of 1901 raced around the corner of University Avenue and headed north, the wooden Episcopal church was destroyed. A new church was quickly built in the same location. It is pictured here around 1903. One of the church's stained-glass windows is dedicated to Theresa Lyndon.

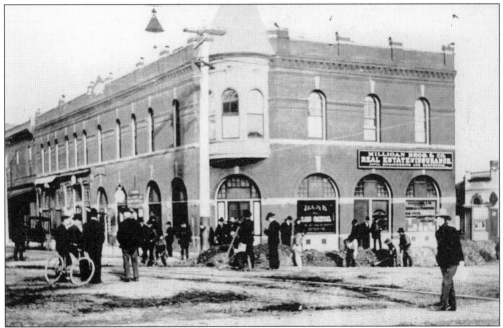

SEWER INSTALLATION. In the late 19th century, Los Gatos was concerned with the "stinking cesspools" that often ripened on the streets of town. In 1904, a local newspaper reported that the community approved a bonded indebtedness of $24,000, of which $20,000 was to be expended in "throwing a bridge across the stream." The other $4,000 was designated for "sewering Los Gatos, thus making it a community of health." Work soon commenced.

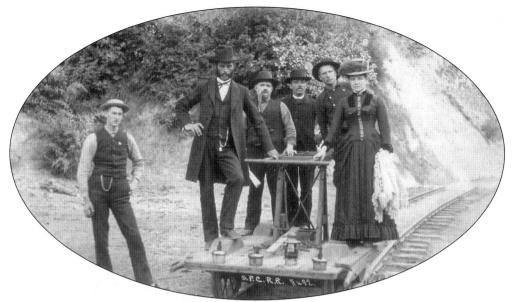

Photo Opportunity. The South Pacific Coast Railroad tracks from Los Gatos to Santa Cruz were completed in 1880, providing passengers with spectacular scenery. Here, a handcar at Wrights serves as a prop for a 1905 portrait. (Courtesy Bancroft Library, University of California, Berkeley.)

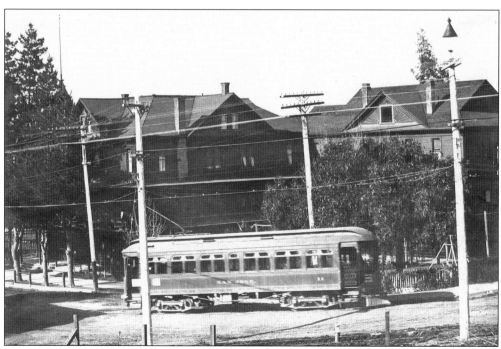

San Jose–Los Gatos Interurban Railway. Los Gatans were pleased when this electric trolley line began service into town in 1904. The "high-speed" trolleys traveled at 30 miles per hour, providing a more comfortable ride around the valley than a stagecoach or buggy. This c. 1905 photograph shows an interurban car near the El Monte Hotel at East Main and Pleasant Streets. The trolleys ran in Los Gatos until 1933.

TOBIN SISTERS. John F. Tobin (1824–1889) and his wife Isabella (1838–1917) settled on East Main Street in 1881. Their daughters are, from left to right, Helen (1869–1955), Janet (1879–1946), and Mary (1878–1960). Janet became well-known for her illustrations of children. She worked for a time in San Francisco, but she returned to Los Gatos to live out her life with her sisters in their childhood home. The sisters never married. (Courtesy Chuck Bergtold.)

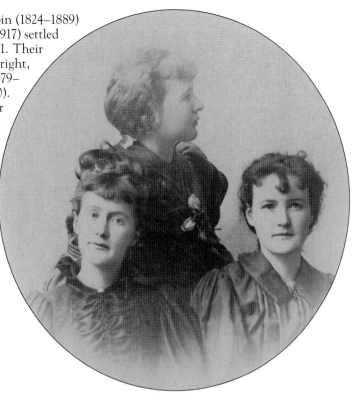

128 EAST MAIN STREET. The Tobin home also served as the town's first news agency. John F. Tobin, who never fully recovered from his Civil War service, was a notary public and a justice of the peace. He served as adjutant of the Los Gatos Edward Otho Cresap (E. O. C.) Ord Post No. 82 of the Grand Army of the Republic. (Courtesy Chuck Bergtold.)

SUMMER IN LOS GATOS. The Tobin family relaxes at home with some unidentified visitors around 1900. Identified are Helen V. (sitting at the left), Isabella Kirkpatrick Tobin (third from the left), Janet A. (petting the dog), and Mary (sitting on the chair arm, third from the right). Isabella was born in London and immigrated to America in 1843 aboard the ship *Huntress*. (Courtesy Chuck Bergtold.)

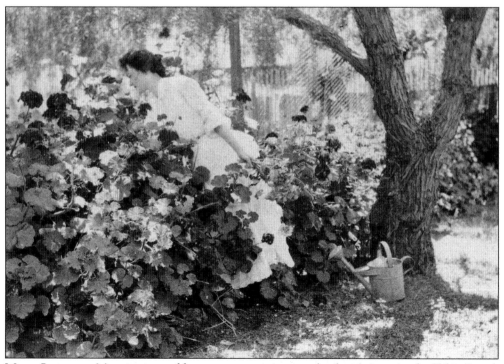

MARY ISABELLA. Mary is pictured here amongst a giant patch of geraniums in the Tobins' yard. The sisters spent their time writing, gardening, and painting, and they made occasional trips to W. S. Walker's mountain ranch, Willow Brook. (Courtesy Chuck Bergtold.)

KIDDIES' SPECIALIST. Janet A. Tobin is pictured here around 1884. A graduate of Los Gatos High School, she designed the cover of the first *Wildcat* yearbook in 1897. Although census-takers usually listed her as unemployed, her art frequently appeared in newspaper advertisements and on greeting cards and postcards. (Courtesy Chuck Bergtold.)

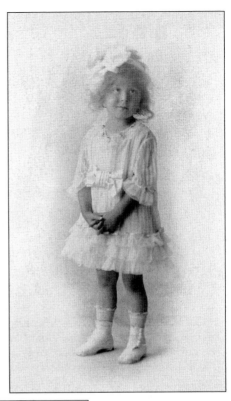

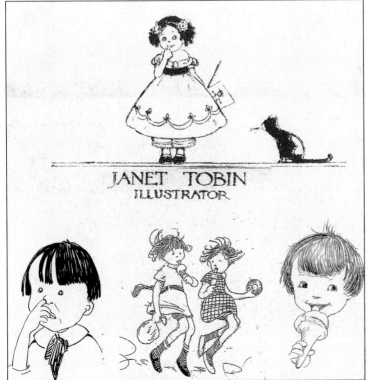

WHIMSY. Janet Tobin's art was often fanciful. Sometimes she signed her work with a more elaborate version of "Janet," becoming "Jeannette" or even "Genett." She died at Agnews State Hospital in 1946 and is buried in the family plot at Los Gatos Cemetery. She remains a recognized artist.

OLD MASSOL HOUSE. This is the original home located at Massol and Saratoga Avenues. It is seen here around 1905, when it was owned by S. D. Balch. Family members pictured are, from left to right, Katherine Cosgrave, Lucy Stiles, Fanny Reiniger, Lucy Balch, S. D. (Dean) Balch, and C. A. Cosgrave. This house was moved across Massol Avenue, cut in two, and made into two cottages. (Courtesy Mary Balch Kennedy.)

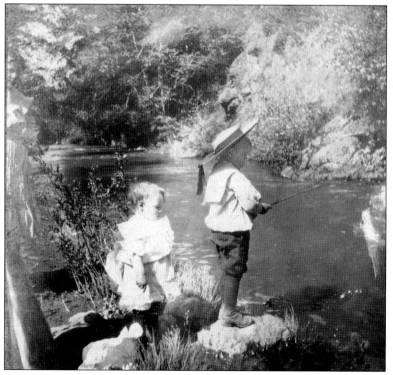

FREDDIE GOES FISHING. A summer day in 1905 finds hometown boy Freddie Berryman (1901–1958) fishing for the speckled trout that were so abundant in Los Gatos Creek. His little sister Alice (1903–1995) looks on. Freddie grew up to be a town councilman and worked for 36 years in the family's plumbing firm, which was founded by his father in 1910.

7.9 IN 1906. A devastating earthquake broke loose from the San Andreas Fault at 5:12 a.m. on April 18, 1906. The damage was more serious in the Santa Cruz Mountains than it was in town, although Los Gatos was badly shaken. Oil wells in Moody Gulch discharged oil for days, which ran down into the creek. Wooden mountain bridges snapped, and lives were lost in landslides. Pictured here are Paul (left) and Cecil Simon, standing in a crevice in a local orchard.

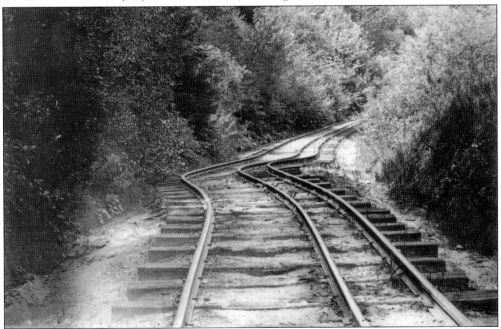

"SHORTENED" RAILROAD TRACKS. A 1906 Magic Lantern slide captured this dramatic image of the railroad tracks just north of Wrights Station, where the distance to Santa Cruz had been "shortened" as a result of the recent earthquake. (Courtesy Bancroft Library, University of California, Berkeley.)

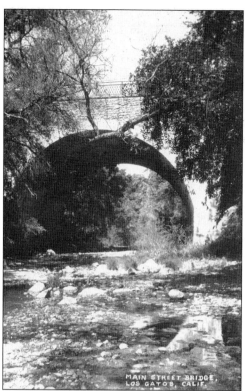

THE NEW BRIDGE, 1906. The old 1882 wooden bridge on Main Street had become unsafe by the time it was replaced by this stone and concrete structure. During its construction, a temporary bridge was built for use by light wagons and carriages, but heavier traffic had to ford the creek at the foot of Miles Avenue.

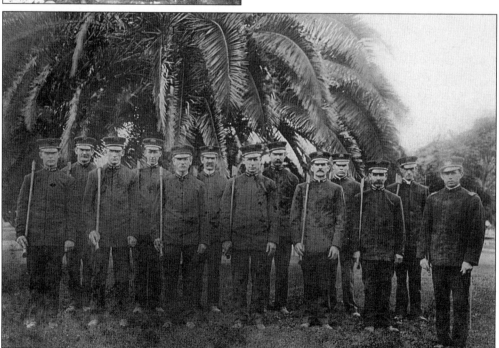

WOODMEN OF THE WORLD, LOS GATOS CAMP 573. Los Gatos members of Woodmen of the World are pictured here around 1905, holding symbolic ax handles. Among its benefits, this fraternal organization provided life insurance. (Courtesy Chuck Bergtold.)

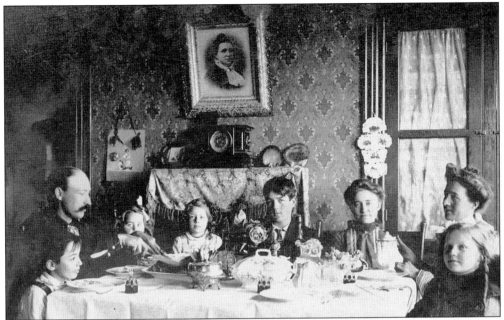

CHRISTMAS ON MARKET STREET. Zephyr Macabee (left) was a successful businessman by the time this photograph was taken around 1906. Opposite him is his wife Elizabeth. The woman sitting next to Elizabeth is probably her sister, Annie M. Baker. They are surrounded by their children. Elizabeth and Annie were dressmakers in Los Gatos before they married.

THE FRETWELL BLOCK. Joseph J. Fretwell (1862–1924) partnered with Alexander F. Place in the late 1880s to establish Place and Fretwell Furniture and Undertaking. That business was destroyed in the 1891 fire. The *Los Gatos News* printed this photograph on October 4, 1907, showing Fretwell in front of his new building on the corner of University Avenue and Main Street, where it still stands today. (Courtesy Chuck Bergtold.)

FINISHING TOUCHES. At a ceremony on March 10, 1908, contractor John Johnson presented the school board with keys to the new high school building. He praised his workers for their harmony and sobriety. David Starr Jordan, president of Stanford University, gave the keynote address. The *Los Gatos News* reported that it was "the strongest temperance speech ever made in Los Gatos." The California Mission–style building stood at the crest of High School Court. (Courtesy Farwell family.)

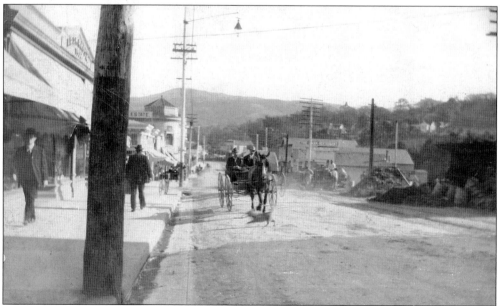

MAIN EVENTS. In this 1908 street scene, damage from the 1901 fire is still evident on the south side of the street. Construction of John Lyndon's Vermont Block has begun. Built of nonflammable brick, the block would house five storefronts that stair-stepped down Main Street to the bridge. *El gato*, or "the cat," is crossing the unpaved street. (Courtesy Chuck Bergtold.)

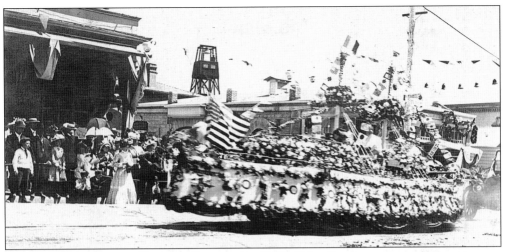

FLORAL CARNIVAL AND FEAST OF LANTERNS, 1909. "No effort to amuse and no expense to promote shall be spared," reported the local newspaper concerning the May Day celebration of 1909. Floats, such as this one on Main Street, were decorated with Santa Clara County flowers. Three smart alecs who persisted in driving a fractious horse around the celebration landed in the town cooler. (Courtesy Chuck Bergtold.)

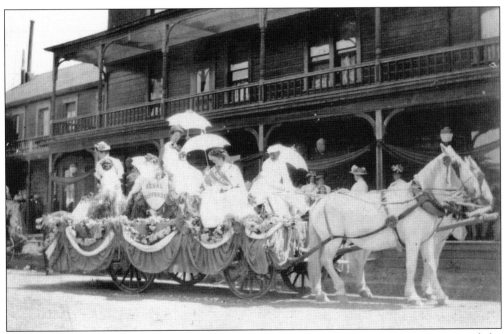

SUFFRAGETTES. The San Jose and Santa Clara County Equal Suffrage Association joined the May Day parade in 1909. Here members are lined up outside the El Monte Hotel waiting for a signal to pull onto Main Street. In the evening, *The Mikado* was sung by local students, who were accompanied by the Victory Theater Orchestra from San Jose.

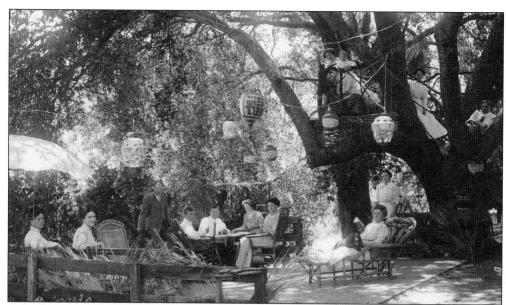

FARWELL FAMILY. The Feast of Lanterns committee encouraged residents to participate by hanging Japanese lanterns in their gardens. Here, the Farwell family is seen relaxing under their display of lanterns, probably at Lyndon Heights. When night fell, the hillsides sparkled. (Courtesy Farwell family.)

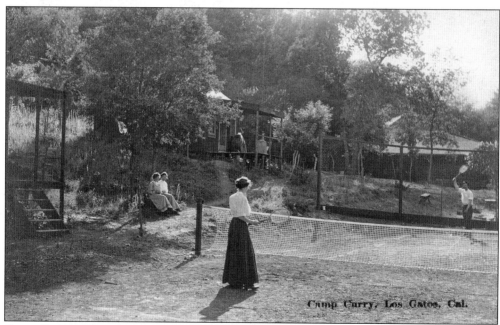

CAMP CURRY. This photograph was taken in 1909, just after the campground opened for the season. It was located south of town in Lyndon Gulch. Four furnished cottages were available for rental, as well as 33 "mostly new" tents.

"HURRAH! WHOOP LA!" The May 27, 1909, *Los Gatos Mail* reacted with that headline when through-mountain train service resumed after being "closed with a bang" by the 1906 earthquake. The quake "smashed in" Wrights tunnel and damaged other tunnels on the line, noted the *Mail*. When the Southern Pacific resumed operations, the rails had been converted from narrow to standard gauge. This is the trestle over Los Gatos Creek, located south of town.

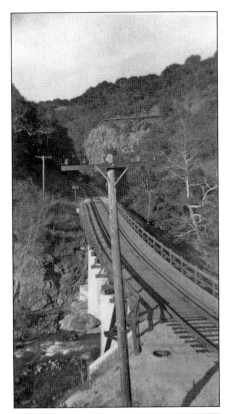

PRUNE BONANZA. Despite warnings from successful businessmen in the 1870s that "fruit was not worth the attention of a sensible man" and not worth clearing the chaparral from the slopes, it proved otherwise. Prunes predominated. However laden with fruit, the trees never broke down, and prunes were the easiest fruit to handle and market.

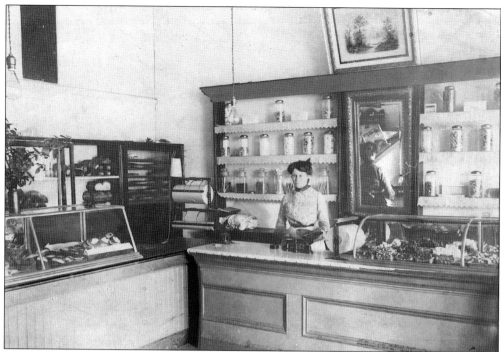

KYLE'S CAPITOLA BAKERY. Located first at No. 5 and later at No. 100 North Santa Cruz Avenue, this business was owned and operated by William J. Kyle (1871–1920), an Irish immigrant. The bakery offered home delivery by horse and buggy. Bakery employee Claire Blabon is pictured here around 1909. She worked at the bakery about 13 hours a day, which was not unusual at that time. (Courtesy Elayne Shore Shuman.)

WE AND OUR NEIGHBORS. In June 1892, a group of farmers' wives from the Vineland and Union area met for afternoon tea at the home of Ann Jane Cilker. That first meeting established an organization so successful that it is still active today. In 1910, Maria Schofield (left), president for 25 years, donated $2,650 to have a Craftsman bungalow built at the corner of Los Gatos–Almaden Road and Union Avenue. The land was sold to the club by Sophia La Montagne (right) for one gold dollar. (Courtesy We and Our Neighbors.)

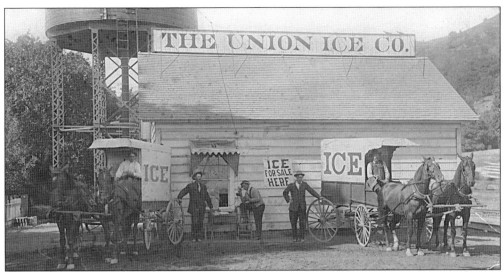

UNION ICE HOUSE. William C. Shore founded the Union Ice Company in 1884 on the east side of the railroad tracks, south of the depot—about where the post office stands today. Three generations of the Shore family ran the business, which moved to Park Avenue in the 1920s. The wagons were used to deliver ice to back-porch iceboxes. (Courtesy Elayne Shore Shuman.)

THE CREEK. The Ambrosini family owned three cabins on the creek south of town, which they rented to summer visitors. In the winter, the water could "boom," running high and rushing with great velocity. Men stationed on the bridge caught driftwood as it came down from the mountains, keeping it from lodging against the structure and causing a washout. (Courtesy Carl Ambrosini.)

79

UNTIMELY DEATH. Frank E. Cilker was 23 years old in 1911 when he died as the result of an explosion that burned him over most of his body. He was the son of pioneers John and Ann Jane Cilker. His obituary called him "the best all-around athlete in the county." His body was brought back to the family ranch, and he was buried at Oak Hill Cemetery. (Courtesy Bea Cilker Hubbard.)

HAULING PEACHES. Robert A. Scott (1893–1918) was raised on his parents' 30-acre peach ranch on National Avenue, neighboring the Cilker ranch. The influenza pandemic of 1918–1919, a global disaster, killed an estimated 675,000 Americans, including 25-year-old Scott. The flu was most deadly for people between the ages of 20 and 40. (Courtesy Alice Scott Fink Chappell.)

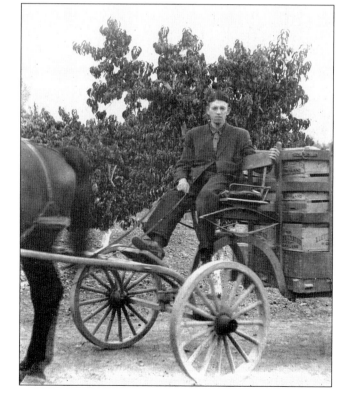

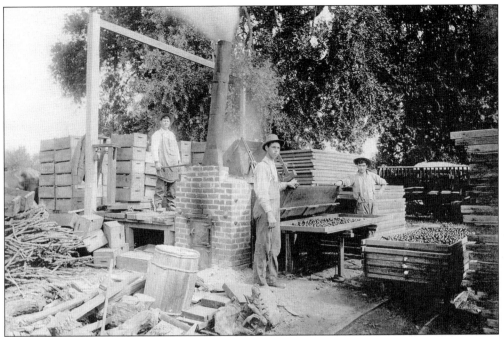

DIPPIN' PRUNES. The George Rawlings ranch, located in the country, halfway between San Jose and Los Gatos, is pictured here on September 1, 1911. The crew is dipping prunes in a solution of lye and boiling water, causing the skins to crack. The prunes were then dumped on wooden trays and hauled to the dry yard. (Courtesy Chuck Bergtold.)

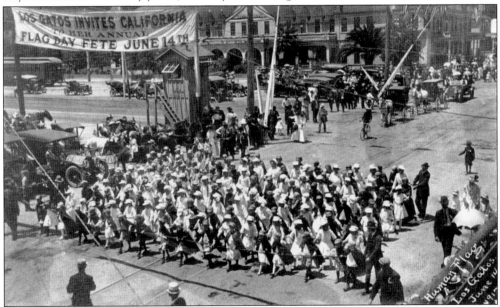

FLAG DAY. A "human flag" of about 100 women dressed in red, white, and blue paraded down West Main Street on June 14, 1912. The Hotel Lyndon sits grandly in the background. An interurban railway car can be seen on South Santa Cruz Avenue, and the 1910 Southern Pacific tower stands guard at the railroad crossing. Several horse-and-buggy rigs are lined up behind the women, but the automobile has clearly arrived.

FROM HORSE-DRAWN TO HORSELESS. In 1900, there were about 20 million horses and only 4,000 automobiles in the United States. By 1913, the *New York Times* declared that the automobile "had changed the face of the earth." This Los Gatos street scene was soon to vanish, a transformation facilitated by Henry Ford's 1908 introduction of his low-priced, highly efficient Model T.

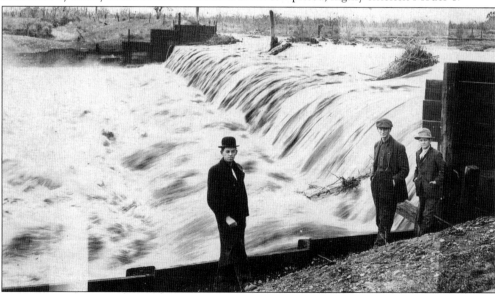

EARLY VASONA DAM. Vasona Lake Dam was completed in 1935. But the waters of Los Gatos Creek had often been diverted, starting in the 1850s, when farmers wanted to irrigate their crops. Wooden flashboard dams, like the one pictured here, existed in the early years. Individual property owners along the creek sold gravel and mining rights. (Courtesy Alice Scott Fink Chappell.)

PARK AVENUE POSE. Ione Shore (1906–1995), daughter of Nellie and Dick Shore, is seen here around 1912 on the stone wall below her Park Avenue home, accompanied by her pets. The stones, gathered from the creek, are still in evidence today. The Shore's handsome bull terrier, named Jess Willard after a prizefighter, models his studded collar. (Courtesy Elayne Shore Shuman.)

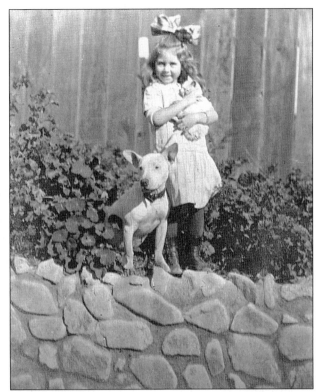

AT THE COMPOUND. In 1904, two pioneer bankers, Dean Balch and James A. Case, bought land at Massol and Saratoga Avenues and created a magical place where their children could raise an assortment of animals, play in the creek, and explore orchards and gardens. Pictured around 1915 are, from left to right, Don Case, Mary Balch, and Bill Balch. (Courtesy Mary Balch Kennedy.)

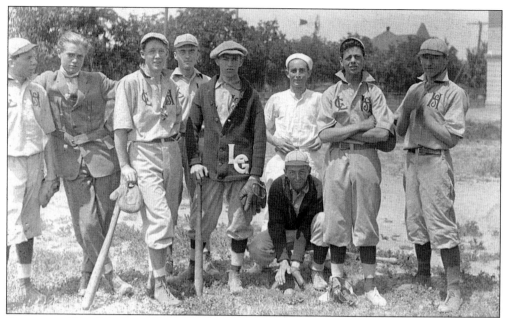

BASEBALL, 1914. Los Gatos High School team members pictured are, from left to right, Romolo Pucchinelli, Harris Sproule, Clinton Suydam, Lyle Holder, Ed Vodden, Cecil Dickinson, Charlie Rugh, and Ernest Riese. Elmer Hardies is in the fielding position. The 1913 yearbook notes that a live bobcat "bought by the boys for a five-dollar bill" served as a mascot at sports events, but it died soon thereafter. (Courtesy *Los Gatos Weekly Times*.)

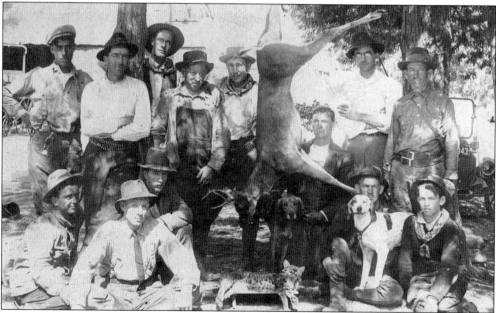

LOMA PRIETA HUNTING LODGE. Posing after a 1914 hunt are Paul Curtis Sr. (standing third from the left), Joseph Mendosa (next to Curtis, in overalls), Dick Shore (kneeling to the right of the deer carcass), his son Melville D. Shore (sitting in the lower right-hand corner), Jack Sullivan, who served as fire chief from 1919 to 1954 (standing fifth from the left), and Dick Blake (standing at the far right). (Courtesy Elayne Shore Shuman.)

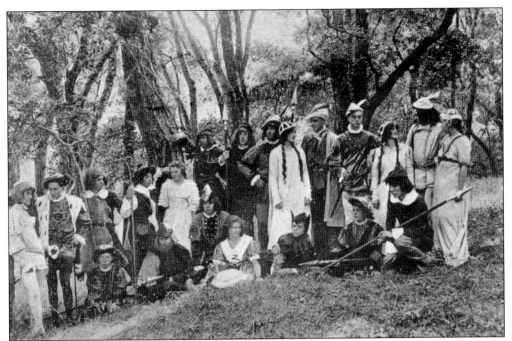

AS YOU LIKE IT. On Friday evening, May 29, 1914, Ford's Opera House was packed for the ambitious presentation of Shakespearean comedy by Los Gatos High School students and friends. The *Los Gatos News* reported that Ruth Alexander won rounds of applause for "her impersonation of Rosalind."

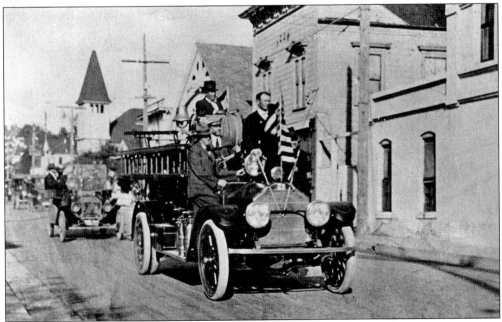

LOS GATOS FIRE DEPARTMENT. A volunteer fire department was organized in 1884. In 1915, the town purchased a La France combination chemical and hose truck, pictured here on West Main Street. J. D. "Dick" Shore, who served as fire chief for 18 years, is standing at the right with his hand on the wheel.

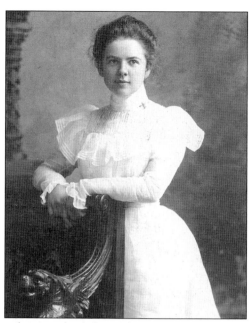

TEACHERS. Dora Mae Rankin (1887–1979), seen here at the left, graduated from Los Gatos High School in 1906 and took her teacher training at San Jose Normal School. She taught for more than 30 years. Her sister Henrianna served as the town's librarian from 1904 to 1909. Erma Irene Simon (1878–1949), seen here at the right, graduated from Los Gatos High School in 1897. Also a teacher, Simon lived on Tait Avenue. Her photograph is dated June 21, 1900. (Courtesy Bruce Franks.)

BLANCHE ARNOLD LIDLEY CURTIS (1893–1981). Blanche starred as the "Spirit of Water" in the 1919 pageant, and she remained active in community events through the years. Her first husband was W. G. Lidley, proprietor of Lidley Pharmacy. Her second marriage was to Paul Curtis Sr., a banker. (Courtesy Paul Curtis Jr.)

MOTHER AND DAUGHTER. Susie M. Walker Kyle (1875–1951), seen here at the left, and her husband William J. Kyle moved into their Victorian home at 127 North Santa Cruz Avenue in 1906. Susie was a superb gardener, and some of her rare specimens have been propagated through the years and still exist. Gladys Kyle Shore (1900–1975), at right, graduated from Los Gatos High School in 1919. An accomplished pianist, she married her high school sweetheart, Melville D. Shore, in 1922, and they lived at 124 Wilder Avenue. (Courtesy Elayne Shore Shuman and Dick Shore.)

GRACE HYDE TRINE (1874–1972). Grace Trine wrote and directed the town's 1923 pageant, *The Mesa Trail.* She was married to author Ralph Waldo Trine. They had homes in New York and Hollywood but lived locally while their son Robert was a student at Montezuma School.

SPRINGTIME IN THE VALLEY OF HEART'S DELIGHT. Photographer J. C. Gordon took this photograph in the 1920s, when the landscape of Santa Clara Valley resembled an immense garden. Orchards produced millions of pounds of prunes, cherries, pears, peaches, and apricots. (Courtesy Chuck Bergtold.)

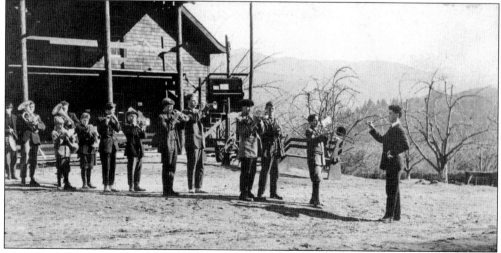

MONTEZUMA SCHOOL BAND. A private boys' school located south of town off Bear Creek Road, Montezuma was proud of its rich curriculum. It existed from 1910 to 1955 and enrolled students from all over the country. Henry Ford visited Montezuma School in 1915 after enjoying a chicken dinner at the Congress Springs Hotel. (Courtesy Scott Rose.)

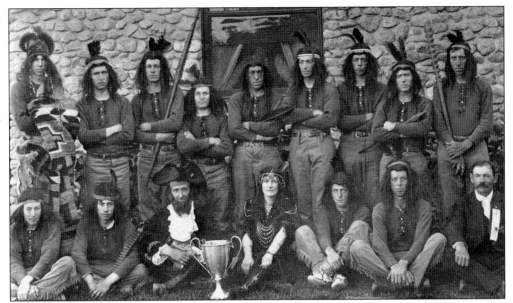

REDMEN LODGE. Members of the Redmen, a fraternal organization, gather around the silver trophy they have just won in a local holiday parade. This *c.* 1918 photograph was taken at the Stone House, at 15 University Avenue, which at that time housed the Wagner Photography Studio. (Courtesy *Los Gatos Weekly Times.*)

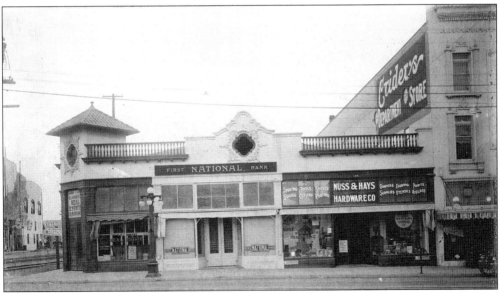

MAIN STREET AROUND 1919. The First National Bank, founded in 1911, occupied this spot for only a short time before the building was replaced with the Renaissance Revival building that still stands at 160 West Main Street. From 1916 to 1957, Crider's Department Store occupied the Ford Opera House.

HOME AGAIN. On August 28, 1918, Fannie Fresher received a sad telegram at her home on North Santa Cruz Avenue. Her son Elmer, serving in France in World War I, had been killed. The war ended less than three months later. This photograph was taken in early 1919. The building behind the group is the 1904 Rankin Block, which still stands.

WATER NYMPHS. With the war ended, hundreds of Los Gatans turned their attention to the first Los Gatos pageant, an outdoor spectacle presented on June 21, 1919. The *Pageant of Fulfillment* proved so popular that pageants continued to be presented most years between 1919 and 1947. Blanche Lidley (top right) played the "Spirit of Water," and her nymphs included Nell Berryman (top left). (Courtesy Paul Curtis Jr.)

Four

BETWEEN THE WARS
1920–1939

MEMORIAL DAY. Paul E. Curtis Sr. (1888–1965) and his future wife Blanche Lidley are pictured in the early 1920s, probably dressed for a parade and ceremony at Los Gatos Cemetery in honor of all who died in the Civil War, the Spanish American War, and World War I. Curtis owned a hardware store, managed Redwood Estates properties, and eventually became president of First National Bank. Blanche, although never a nurse, was equally community minded. (Courtesy Paul Curtis Jr.)

WAITIN' AT THE STATION. The sights and sounds of a train steaming into the station cast a spell, and watching who was coming and going was entertainment. The veranda of the Hotel Lyndon was a good observation point. In the case of this unidentified girl, a seat on a baggage cart also worked well. The first depot, pictured here, served from 1878 to 1924, when it was remodeled by the Southern Pacific Railroad.

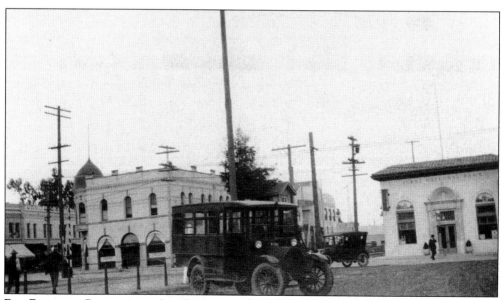

PRE-PEERLESS. Bus service in Los Gatos started in 1915, when Floyd N. Curtis purchased three Ford touring cars. The cars ran between Los Gatos and San Jose. The Ford Model T in this *c.* 1920 photograph had facing seats. Curtis and his brother George also offered automobiles for hire. (Courtesy Chuck Bergtold.)

HOT WHEELS. This two-wheeled invention was still quite new when Joseph Scott (1894–1966), seen here at the right, posed on his Harley Davidson in front of the packing sheds of the Scott ranch on National Avenue around 1912. Emery Main (1883–1955) is on his Indian motorcycle. Time for riding came only after all the farm work was done. (Courtesy Alice Scott Fink Chappell.)

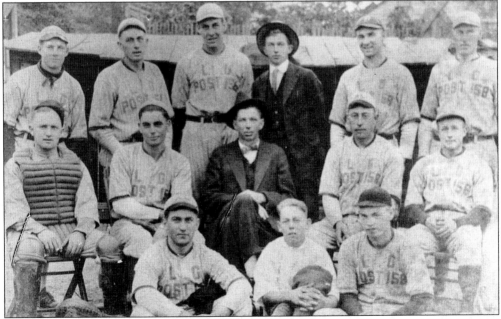

LOS GATOS LEGION NINE. Post 158 of the American Legion sponsored this team in 1922. Pictured from left to right are the following: (first row) Roy Emerson, batboy David R. Matheson, and Melvin "Dee Dee" Vodden; (second row) Mel Pratt, "Penny" Oliver, manager Roy Sporleder, Oliver Nino, and Roy Chittick; (third row) Harold Peterson, Bud Lord, Pat Mullen, secretary and scorekeeper Ed Kennedy, Walt Williams, and unidentified. (Courtesy Farwell family.)

SPEEDWAY. The new concrete highway to Santa Cruz opened on August 26, 1921. "It's almost like a race course," said contractor J. L. Connor. "Automobilists will be tempted to speed." Twenty "speed cops" were hired to enforce the speed limit of 20 miles per hour. The railroad tracks, seen here at the left, ran parallel to the highway. (Courtesy Farwell family.)

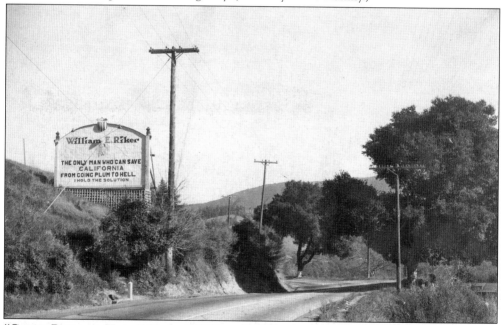

"GOING PLUM TO HELL." "Father" William E. Riker, potentate of Holy City on the old Los Gatos–Santa Cruz Highway, promised the perfect solution to every problem. The 1930 census shows 39 people living in his compound; they were mostly men, and their average age was 50. Riker's followers believed in his utopian ideas enough to turn over their life savings to him. For most, Holy City served as a fascinating, if bizarre, stop on the way to Santa Cruz.

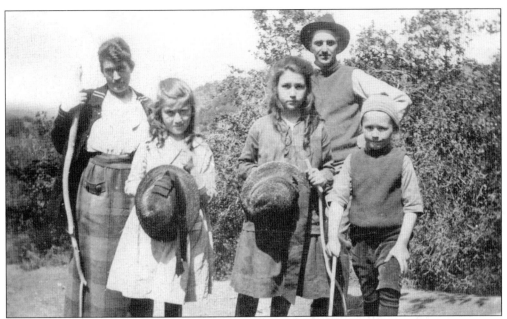

HIKING THE HILLS OF LOS GATOS. The James A. Bacigalupi family is shown here around 1922. From left to right are Mary Ellen Jones Bacigalupi (1884–1974), Jeanne Marie (1912–1996), Louise (1910–2003), James A. Bacigalupi Sr. (born in 1883), and James Jr. (1914–1992). James Sr. was president of the Bank of Italy from 1924 to 1929, and then worked with A. P. Giannini to form the Bank of America. (Courtesy Farwell family.)

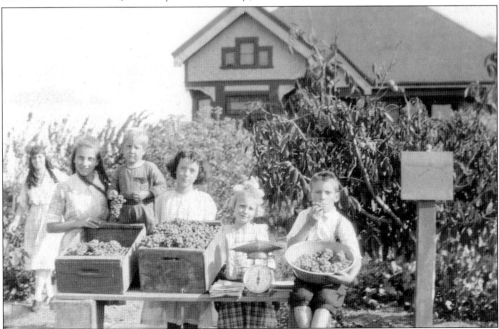

GRAPES APLENTY. Nearly every type of fruit grew to perfection in the Santa Clara Valley. A natural outcome was the roadside fruit stand, captured here around 1922 on San Jose–Los Gatos Road. The children are, from left to right, Gertrude Fink, Kathryn Fink, Lester Fink, Anna Brickmont, Margaret Fink, and Victor Fink Jr. (Courtesy Alice Scott Fink Chappell.)

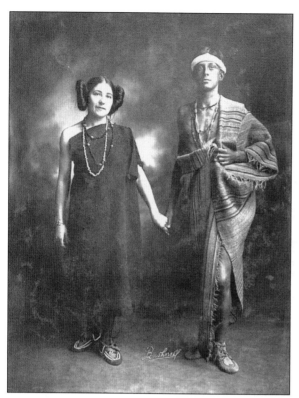

THE MESA TRAIL, 1923. "Last night they had a pageant in town and of course we all went," wrote author Kathleen Norris. "For days the whole town has been boiling over with the excitement of the thing, and little girls' heads have been in curl papers, and all the youths have been practicing the snake steps, and all the maidens have been twining their locks about drums, and sewing primitive red stripes upon primitive black and yellow shawls." Delia Puccenilli and Hobart Furman (shown here) played young lovers in this pageant, which was written and directed by Grace Hyde Trine. A Hopi village was recreated on stage in front of 5,000 seats, and many of the actors wore period Native American clothing. Kathleen and Charles Norris, Ruth Comfort Mitchell, and Sanborn Young were cast members.

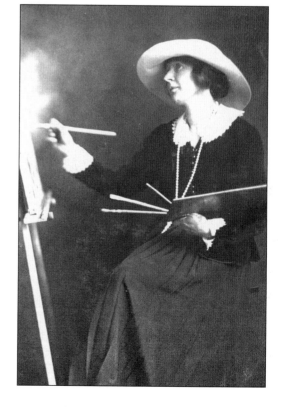

ARTIST IN RESIDENCE. Local artist Janet Tobin participated in *The Mesa Trail* pageant by playing the leader of an artists' colony. The *San Jose Mercury Herald* reported, "Throughout the three acts and interludes, the stage was a kaleidoscopic riot of vivid colors."

EL GATO DE LOS GATOS, 1924. Set in the vicinity of Los Gatos in the idle, splendid 1830s, this play sought to recreate life on the ranchos during the golden age of the dons, a pastoral, romanticized era of fiestas and hospitality that took place under Mexican rule from 1822 to 1846. Here, Carmencita Riz (played by Patience Hostetter, who later married Martin LeFevre) strikes a pose with Hernando de Hernandes (played by Carl Gertridge).

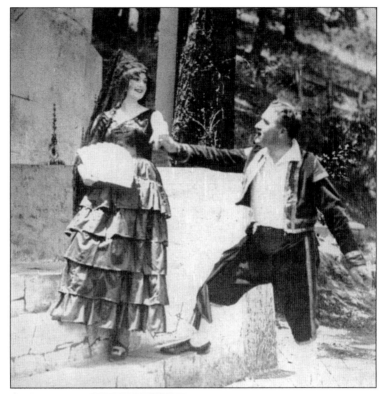

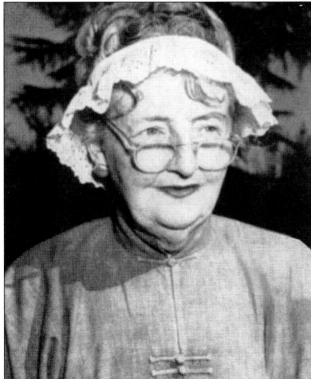

DICK WHITTINGTON'S CAT, 1947. Kathleen Thompson Norris (1880–1966), known as the "Grande Dame of Serial Fictioneers," wrote 90 books over a half-century career. She authored the script for the 1947 pageant and appeared as "Mama Cat" in the 1946 pageant *The Cats*, as seen here. She first appeared in a local pageant in 1922, when the *Pageant of Fulfillment* was reprised.

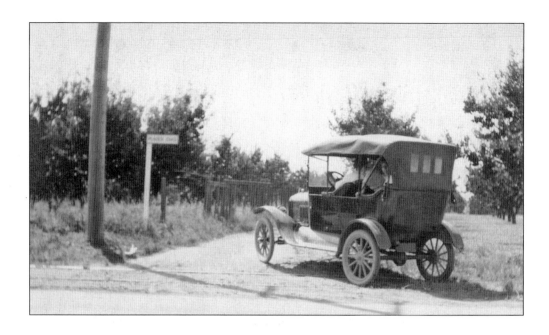

PLACER OAKS RANCH. The Charles H. Bergtold family came to Los Gatos around 1922 and settled on an idyllic acreage they called Placer Oaks Ranch. Charles Bergtold (1870–1926) and his wife, Louise Corkill Bergtold (1884–1967), had an early dairy on their land, which overlooked Los Gatos Creek. The Bergtold's Model T carried them home, where they might have dined under the blossoms or gathered around the tank house for a photograph. An original millstone from Forbes Mill found its way to the Bergtold ranch. It was donated to the museum in 2005. The two Bergtold sons, Fred and Lyman, graduated from Los Gatos High School. (Courtesy Phillip Bergtold.)

FRESHMEN, 1922–1923. Taking a break from a basketball game in front of the 1908 high school building are, from left to right, the following: (first row) Mary Balch, Marian Easterbrook, Margarite Lawrence, and Ida Lawrence; (second row) Phoebe Van Lone, Victoria Rosasco, Lucile Burt, and Helen Poncia. The girl in the center is unidentified. This was the first stand-alone high school in town. (Courtesy Mary Balch Kennedy.)

MAGGIE MAY FINK (1889–1956). The Shannon Road ranch of Victor and Maggie Fink is pictured here around 1923. The home was constructed c. 1872 by sea captain Melvin S. Gardner (1814–1878). Maggie married at age 16 and became the mother of seven, including youngest son Lester, pictured here. After milking the cow, Maggie would hurry to make dinner for her family. (Courtesy Alice Scott Fink Chappell.)

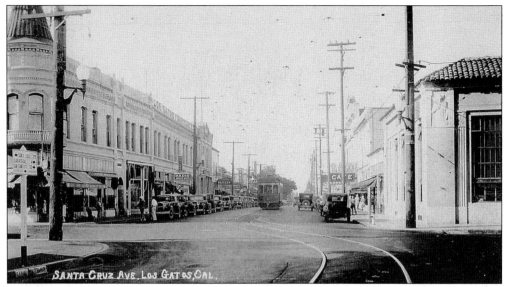

BIG RED. The easiest way to get to San Jose in 1925 was to hop aboard the San Jose–Los Gatos Railway and travel past farms and orchards in relative luxury. The electric trolley cars were large and cumbersome and could snarl traffic, but springtime trips through a sea of blossoms were memorable. (Courtesy Chuck Bergtold.)

ROADSIDE ATTRACTION. Charles Erskine Scott Wood and Sara Bard Field, seeking refuge from their tumultuous lives, came to Los Gatos in 1919. They checked into the Lyndon Hotel and soon met real estate agent Zedd Riggs. In 1931, Wood wrote, "God, who I suspect is interested in Los Gatos as one of his favored spots, led us through the door to Mr. Riggs." When they drove up the road that would become the entrance to The Cats estate, Wood said "Alabama!"—meaning "Here we rest." An unidentified boy stopped to admire one of the 8-foot-tall cats guarding the entrance around 1930.

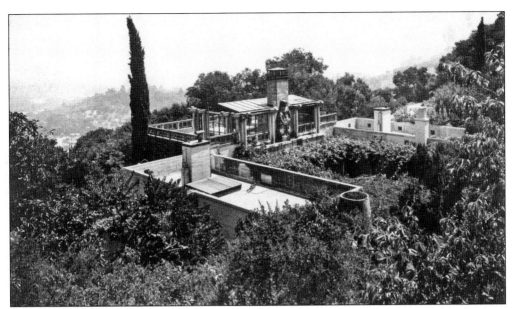

THE CATS. Architect Walter Steilberg's design made extensive use of concrete blocks. Sara Bard Field said that the home's seclusion and comfort were perfect but that it "had a great deal of trouble with leakage." All of the building materials were hauled up the steep hill with horses and wagons. Wood and Field moved into their sumptuously furnished hillside retreat in 1926. (Courtesy Huntington Library, San Marino, California.)

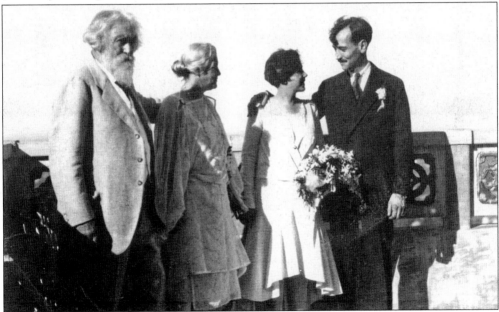

THE BEAUTIFUL WEDDING. Ansel Adams photographed the wedding of Sara's daughter, Katherine Ehrgott, to James Ralston Caldwall at The Cats on September 1, 1929. At left are Wood and Field. "The day of days was here, flawless, golden, winey, beautiful and clear as a Mexican opal," Wood wrote. The hillside was "a carpet of the most wonderful rose-colored and dark purple and wine-colored petunias . . . all smelling like Paradise itself." (Courtesy Huntington Library, San Marino, California.)

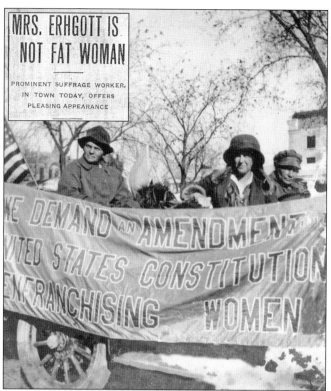

MRS. ERHGOTT IS NOT FAT WOMAN

PROMINENT SUFFRAGE WORKER, IN TOWN TODAY, OFFERS PLEASING APPEARANCE

WE DEMAND AN AMENDMENT TO THE UNITED STATES CONSTITUTION ENFRANCHISING WOMEN

"**MRS. ERHGOTT IS NOT FAT WOMAN.**" That headline met Sara Bard Field Ehrgott when she arrived in Washington, D.C., in 1915. It was written by a reporter who misspelled her name and was surprised at her appearance. She had just crossed the continent in an overland automobile, accompanied by two Swedish feminists, to deliver to Pres. Woodrow Wilson a half-million signatures in favor of women's suffrage. Ehrgott (second from the right) suggested the slogan "No votes, no babies!" She divorced her Baptist minister husband when she no longer agreed with his fundamentalist ideas and had fallen in love with C. E. S. Wood. (Courtesy Huntington Library, San Marino, California.)

NANNIE MOALE SMITH WOOD. Charles Erskine Scott Wood married Baltimore belle Nannie Smith in 1878, and they had six children. They settled in Portland, Oregon, in 1884, where Wood practiced law. Nannie Wood chose not to acknowledge her husband's affairs with other women and would never agree to divorce. The Woods are pictured here in 1928 at Camp Sherman, Oregon, with their grandchildren. Nannie Wood died in 1933, and C. E. S. Wood married Sara Bard Field in 1938. (Courtesy Oregon Historical Society.)

LITTLE STAR. In 1929, Beth Grover, age 19, arrived at The Cats, riding in Sissy Seaman's roadster with pigskin seats. From a Russian refugee family, Beth Grover became a swimming star at age seven in Portland, Oregon, performing with seals at the Pantages Vaudeville Theater and demonstrating water stunts for the newsreels. She met divorcée Kitty Seaman Beck at a swimming pool in 1917 and was subsequently "adopted" by Kitty and her sister Sissy. When C. E. S. Wood engaged Sissy to assist in writing the biography of his father, the first surgeon general of the U.S. Navy, Beth Grover came along to Los Gatos, where she became a reporter for the *Mail-News*. (Courtesy Beth Grover Rondone.)

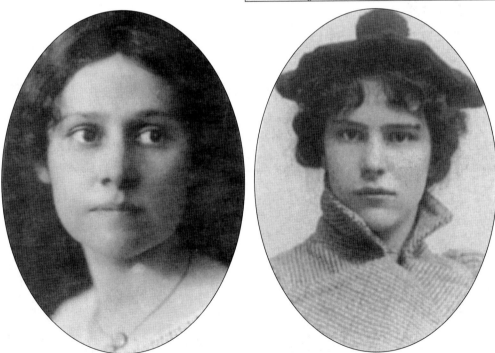

KITTY AND SISSY. Katherine "Kitty" Seaman Beck Irvine (1885–1923), seen here at the left, was 17 years old and recently divorced when she was hired as C. E. S. Wood's private secretary in Portland. She and Wood began an intermittent long-term affair. In 1911, she married an alcoholic physician in reaction to the appearance of Sara Bard Field in Wood's life. This second marriage was also ill-fated. She was living near Seattle with radical lawyer George F. Vanderveer when she was either murdered or committed suicide. Emily G. "Sissy" Seaman (1883–1973), at right, and Wood never completed their biography of Wood's father. (Courtesy Beth Grover Rondone.)

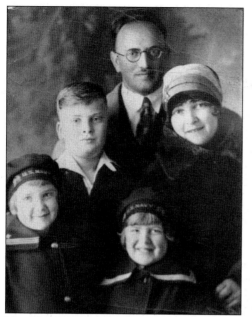
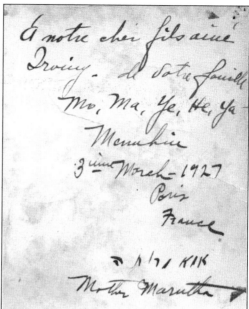

MO, MA, YE, HE, YA. Yehudi Menuhin (1916–1999), at center left, was already a famous violinist when this family portrait was sent to Los Gatos from Paris in 1927. The young genius is surrounded by his parents, Moshe and Marutha, and his sisters (in no particular order) Hephzibah and Yalta. The Menuhins bought their home near the novitiate in 1936. As an adult, Yehudi maintained a home near Alma. (Courtesy Eleanor Sussman.)

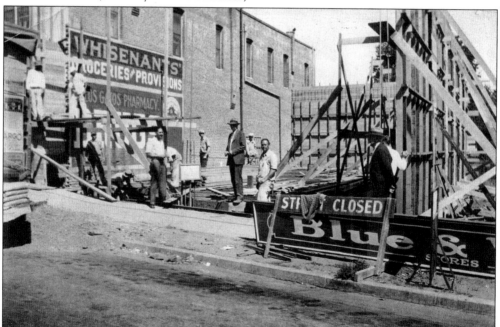

MAIN MAN. William John Whisenant (1897–1971) stands at the center of this *c.* 1929 photograph, smoking a cigar and surveying his latest project, a building at 49 East Main Street. When Whisenant arrived in Los Gatos in the 1920s, he purchased the 1890s building at left to house a pharmacy, grocery store, and soda fountain. (Courtesy Chuck Bergtold.)

Strand Theatre
Los Gatos
Tuesday and Wed.,
April 12th and 13th

One of the Best Pictures of the year

Save Friday evening, April 29th.
"Public Schools' Week" Program
High School Auditorium
SAVE THE DATE

MOVING PICTURES. The Strand Theatre opened on Santa Cruz Avenue on Saturday evening, November 18, 1916, and 900 people showed up for the 600 seats. The lessee of the new theater in the Marshall Building, Mrs. R. M. Black, announced that she would run an up-to-the-minute picture house, showing films of the highest and cleanest type. This 1927 advertisement features Clara Bow, said to have invented the notion of sex on the silver screen. (Courtesy Chuck Bergtold.)

GUADALUPE QUICKSILVER MINE. On May Day, 1927, two couples posed on an abandoned smelter. Guadalupe mine was located off Hicks Road on the Capitancilles Creek, a few miles west of its famous sister mine, New Almaden. The mine began production in the mid-1850s, and by 1858 it was producing 200 flasks of quicksilver per month. The mine was idle for about 20 years because of litigation over ownership of the land.

"MOTHER LUCILLE." Lucille Jensen Riker was the wife of William E. Riker, the infamous and eccentric founder of Holy City, located 10 miles south of Los Gatos. She was never a nun, but she was an aspiring author, as demonstrated by this 1930 self-published booklet. She died in 1950. (Courtesy Chuck Bergtold.)

TOWN FAVORITE. Chief was a dog of uncertain lineage who endeared himself to Los Gatans in the 1930s and 1940s. For at least 10 years, he was a regular "student" at Los Gatos Union Elementary School, favoring the fourth-grade curriculum. Everyone in the town of "the cats"—about 3,500 people—knew this dog.

TWO JOES. On the day in 1931 that Joseph Doetsch Jr. received his engineering degree from Santa Clara University, he returned to the family ranch in north Los Gatos, put on his work clothes, and set to work washing out wooden apricot trays. Young Joe Nishimura stands at his side in this image, which is symbolic of the long relationship between the two families. The Doetsches purchased their ranch in the early 1920s. With the help of the Nishimuras, they had a yearly production of 400 tons of apricots, prunes, almonds, grapes, and strawberries from their land, which is now under Vasona Lake. When the Nishimuras returned from internment at Heart Mountain, Joe Doetsch Sr. helped them reestablish their lives. (Courtesy Joseph Doetsch Jr.)

CITIZEN FARWELL. James D. Farwell (1872–1943) was vice president of the Bank of Los Gatos, manager of the Glen Una prune ranch, president of the Los Gatos Telephone Company, and the man who purchased the town's fire bell. He donated land to the school district and for the expansion of Memorial Park. His father was a sea captain and a member of the 1850s San Francisco Vigilance Committee, formed to combat lawlessness. (Courtesy Farwell family.)

LOS GATOS TELEPHONE COMPANY. A telephone exchange was located in the J. H. Coult drugstore, located on the current site of the Beckwith Block, as early as the mid-1880s. When Coult's business was destroyed in the 1891 fire, telephone service moved to other locations. These 1934 Los Gatos Telephone employees are Ted Hartman (left), construction foreman Roy Sporleder (center), and an unidentified person.

CLASS OF 1934. Pictured here as sophomores in 1932, this Los Gatos High School class could boast of an international star and a local favorite. Olivia de Havilland (first row, second from the right) went on to a distinguished film career, including her unforgettable portrayal of Melanie Hamilton in 1939's *Gone With the Wind*. Her friend John Baggerly (top row, far right) was a beloved local newsman. He died in 2002.

AMERICANA. In 1944, San Francisco photographer Phil Fein came to town to capture a series of images of Chief, the dog who went to school. With Chief are fourth graders Phyllis Whittaker and Joseph Facchino, entering what is now the Old Town shopping center.

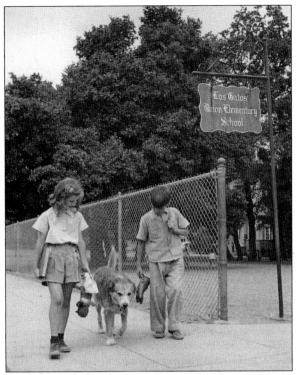

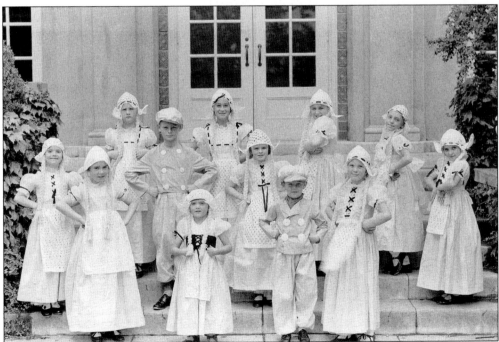

DANCING DUTCH. This c. 1935 dance troop, under the direction of Betty McClendon, was photographed at University Avenue School. Joyce Macabee (first row, second from left) is the granddaughter of Zephyr Macabee. On the step above her is Paul Curtis Jr., who became a beloved dance instructor. (Courtesy Joyce Macabee Ridgely.)

CAROLINE ON A CRUISE. Caroline Earle Baggerly (1874–1959) is seated on the far right in this 1937 shipboard photograph. Caroline and her husband, Hiland L. Baggerly (1870–1944), were world travelers. "Hy" Baggerly began his career working for his brother-in-law Fremont Older on the *San Francisco Bulletin*. In the early 1920s, Baggerly bought the *San Jose News*. He acquired the *Los Gatos Mail-News* in 1927. (Courtesy *Los Gatos Weekly Times*.)

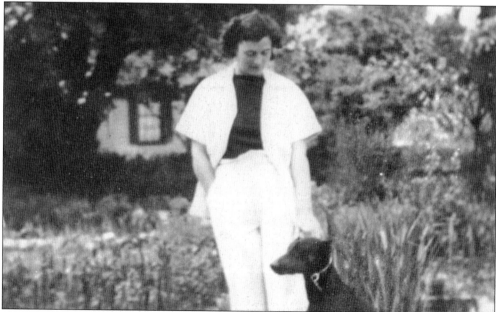

CAROL HENNING STEINBECK. John and Carol Steinbeck came to Greenwood Lane (now Monte Sereno) in 1936. Carol was an artist and poet in addition to being her husband's typist and most perceptive critic. In 1938, the couple moved to the secluded 47-acre Biddle Ranch in the Santa Cruz Mountains, where Carol and Bruga the dog were photographed before the end of August 1941. (Courtesy Martha Heasley Cox Center for Steinbeck Studies, San Jose State University.)

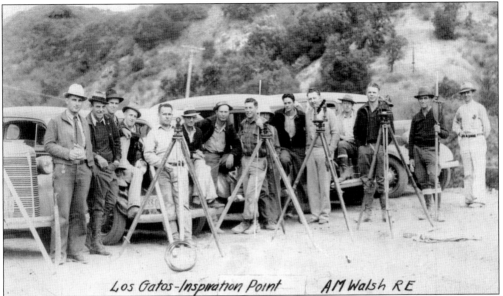

Los Gatos-Inspiration Point AM Walsh RE

INSPIRATION POINT. Engineers and surveyors of the California Department of Public Works' Division of Highways overcame rugged terrain and complicated geological formations when they widened and realigned the Los Gatos–Santa Cruz Highway in the 1930s. A project team is pictured here in 1938 at Inspiration Point, a location that now exists as a pull-out area near Glenwood Road on Highway 17. Original plans for a bridge across Moody Gulch proved too costly and impractical.

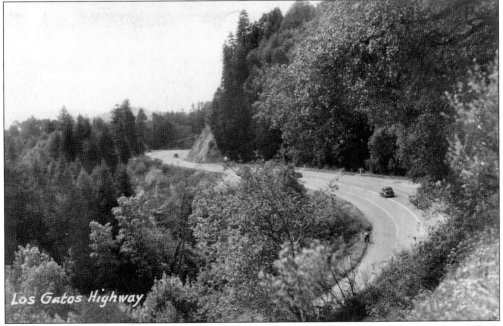

Los Gatos Highway

ROUTE 5. When the new highway to Santa Cruz (now called Highway 17) opened on July 5, 1939, the number of curves had been reduced from 130 to 22, eliminating the equivalent of 17 complete circles. The last 1.8-mile stretch through Cats' Canyon and into town was challenging due to steep terrain and the proximity of the railroad tracks. It took another year to complete.

AT YOUR SERVICE. This handsome 1939 La Salle ambulance was purchased by George B. Place, whose family provided undertaking and funeral services to the town for three generations. Local lore indicates that the La Salle was kept in a highly polished condition, like a fire engine. Corpses weren't allowed in the La Salle—they were picked up in a Chevrolet. (Courtesy Chuck Bergtold.)

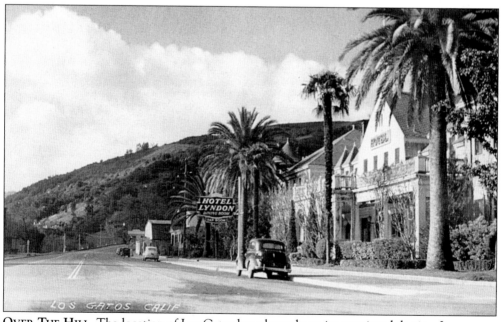

OVER THE HILL. The location of Los Gatos has always been its appointed destiny. It serves as a gateway from the riches of the Santa Clara Valley through the mountains to the sea. It was a way station for the lumber and fruit industry, a stagecoach stop, and a rest stop where locomotives took on water before starting up "the hill." Its beautiful foothill setting always has drawn people to it. (Courtesy Scott Rose.)

Five

THE GROWTH YEARS
1940–1959

TRAIL DAYS, 1940. Owen Atkinson, a local writer for both magazine and screen, was engaged to write the script for the *Trail Days* pageant. It was presented on Friday evening, August 23, 1940, at the pageant grounds, where a new amphitheater had been constructed by the Works Progress Administration. "Los Gatos celebrated with a vengeance," said the *Los Gatos Times*. The occasion was the completion of Highway 17 from the town limits into Los Gatos proper, which eliminated a serious bottleneck. Appropriately, the story of the pageant recalled how the road over the mountain was opened free to the public after angry teamsters tore down the toll gate in 1877.

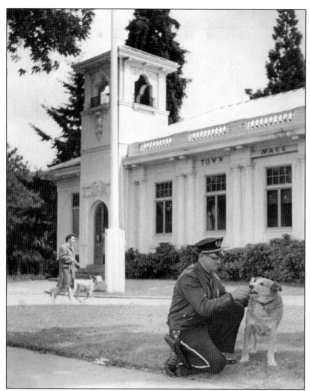

EXEMPT. Los Gatos had a leash law in the 1940s, but the town dog, Chief, was apparently not informed. The infraction could not have been too serious, given this documentation of police chief Ralph Phillips feeding "the other Chief" a cookie in front of the 1913 town hall.

GYMKHANA PARADE. The town's newly established association of horse enthusiasts led a parade at noon on August 24, 1940, as part of the Trail Days celebration. About 200 horses and riders participated. The parade was followed by a horse show and competition at the arena, which was located along Los Gatos Creek. Crall's Stationery is seen at the center of this image.

SMALL TOWN, BIG WAR. Disbelief gripped the country on December 7, 1941, as word spread that Japan had attacked the U. S. Navy at Pearl Harbor. The Los Gatos Civilian Defense Council issued the order for a mandatory blackout three days later. Some feared that an attack on the West Coast was imminent. Life had irrevocably changed, and people began to accept that the country was at war. (Courtesy Chuck Bergtold.)

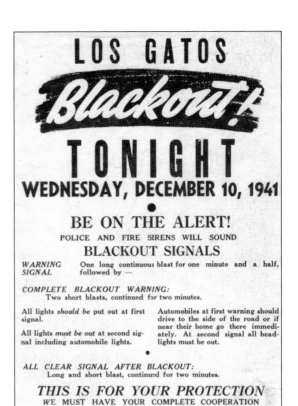

LOS GATOS
Blackout!
TONIGHT
WEDNESDAY, DECEMBER 10, 1941
●
BE ON THE ALERT!
POLICE AND FIRE SIRENS WILL SOUND
BLACKOUT SIGNALS

WARNING SIGNAL — One long continuous blast for one minute and a half, followed by —

COMPLETE BLACKOUT WARNING:
Two short blasts, continued for two minutes.

All lights *should be* put out at first signal.

All lights *must be out* at second signal including automobile lights.

Automobiles at first warning should drive to the side of the road or if near their home go there immediately. At second signal all headlights must be out.

●

ALL CLEAR SIGNAL AFTER BLACKOUT:
Long and short blast, continued for two minutes.

THIS IS FOR YOUR PROTECTION
WE MUST HAVE YOUR COMPLETE COOPERATION

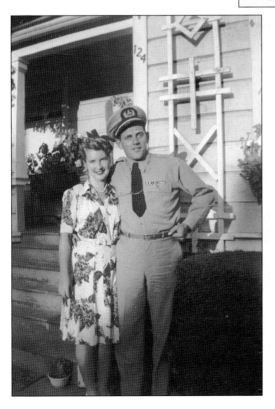

AMERICAN CLASSIC. Harold M. Shuman and Elayne C. Shore are pictured in front of 124 Wilder Avenue in October 1945. Harold was about to leave on his final assignment with the Merchant Marines, a voyage that took him around the world on the S.S. *Salina* victory ship. During his more than three years of active service, he was aboard two torpedoed ships. He returned safely, and the couple married in 1946. Harold died shortly after the 1989 Loma Prieta earthquake destroyed the Shumans' Los Gatos home. (Courtesy Elayne Shore Shuman.)

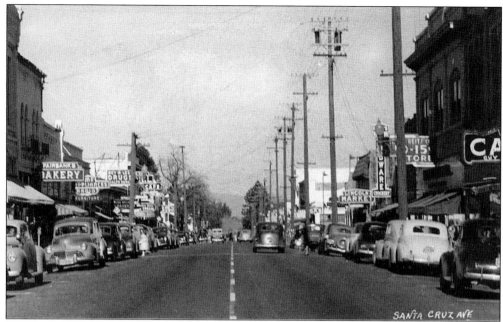

RECOVERY. The Los Gatos Salvage For Victory committee collected tons of scrap metal for the war effort. Food, gas, and even clothing were rationed. Things were looking up a bit when this photograph of North Santa Cruz Avenue was taken around 1946. Templeman's Hardware advertised, "Post-War Appliances—They're Here At Last!" Los Gatos Telephone and Beatrice Creamery were hiring, and Lyman Feather's Star Taxi would deliver groceries to your home for 15¢. (Courtesy Scott Rose.)

THE LAND. Long before it was known as the Santa Clara Valley, the land was covered by a majestic oak forest. The Spaniards began to cut the oaks in order to plant crops and graze their cattle and horses. The Americans arrived and planted wheat. That soon changed, when it was discovered that there was no place better in the world to grow fruit. But by about 1960, scenes such as this one were vanishing.

116

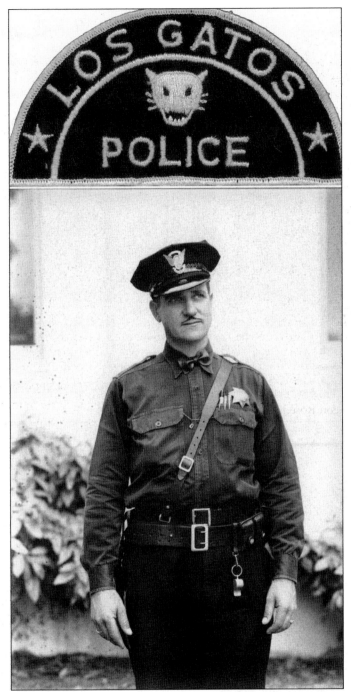

THE CHIEF. Ralph M. Phillips (1905–1981) served as chief of police for 27 years, from 1943 to 1970. His was the longest tenure in town history. He is remembered for his involvement with the Los Gatos Gymkhana Association. He often led colorful parades of hundreds of horses and riders through town. The horse arena was in the area of the current Town Corporation Yard. For several years there were rodeos, complete with bronco busting and steer roping. Chief Phillips owned a 17-acre ranch on Blossom Hill Road.

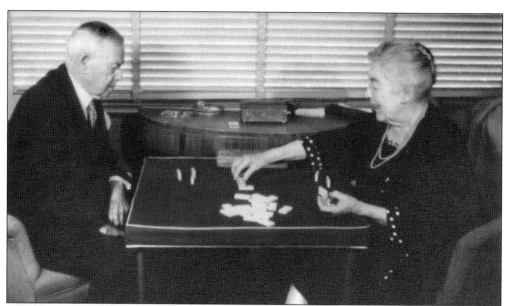

RUTH COMFORT MITCHELL AND SANBORN YOUNG. A prolific and popular writer, Ruth Comfort Mitchell (1882–1954), pictured here with her husband, authored 16 novels and numerous poems, short stories, and plays. She denounced John Steinbeck's views in *The Grapes of Wrath* and wrote a novel titled *Of Human Kindness* "to tell the ranchers' side." Living within a few miles of each other, the two writers had philosophies that were worlds apart.

JOLLY DAYS. Ruth Comfort Mitchell and Sanborn Young were both active in Republican politics: she was the national committeewoman from California, and he was a state senator from 1926 to 1938. Their unique home on Cypress Way was a showplace of Chinese design and featured pagoda-style roofs, as illustrated in this postwar holiday greeting card. Herbert Hoover was a frequent guest.

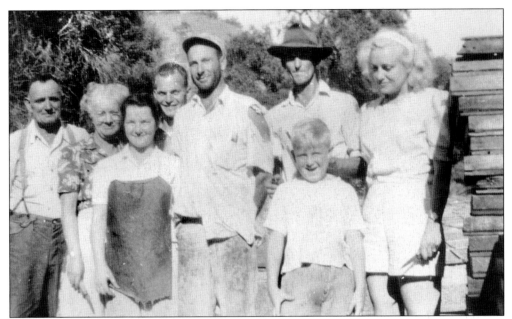

CUTTING 'COTS. At harvest time, neighbors helped neighbors. Gathered at the McKinley ranch on upper Shannon Road in 1947 are, from left to right, Johnny and Pearl Panighetti, Vera McKinley, Norman Handley, Lester Fink, Mike McKinley, and Alice Fink. Lester Fink drove the local school bus for 46 years. Ron Fink, who stands in front, has managed the Macabee Gopher Trap Company in Los Gatos for more than 40 years. (Courtesy Alice Scott Fink Chappell.)

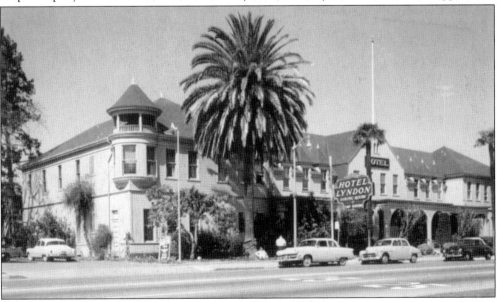

LANDMARK. Between 1954 and 1968, Los Gatos lost many keystone structures: Carnegie Library in 1954; the Main Street stone bridge and Memorial Park in 1955; the Baptist church at Main Street and College Avenue in 1958; the Hotel Lyndon (pictured here) in 1963; the Southern Pacific Railroad depot in 1964; the old town hall in 1966; and the old Methodist church on Church Street in 1968. The ornate 1913 town hall, with its twin belfries and a little cement jail house, stayed in place until the current civic center opened in 1966.

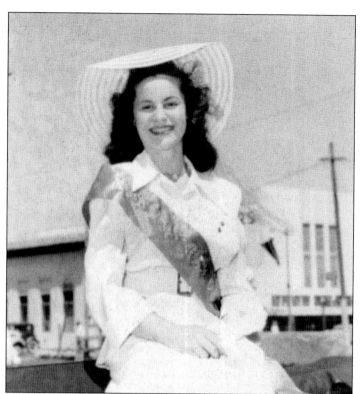

CENTENNIAL QUEEN. Pat Eperson was queen for the day on July 2, 1949, when Los Gatos celebrated the anniversary of the 1849 adoption of the first California constitution by the territorial government at Colton Hall in Monterey. The centennial parade, with 80 entries, wound its way through town on that sunny Saturday. Crider's Department Store (the opera house) is seen at the right.

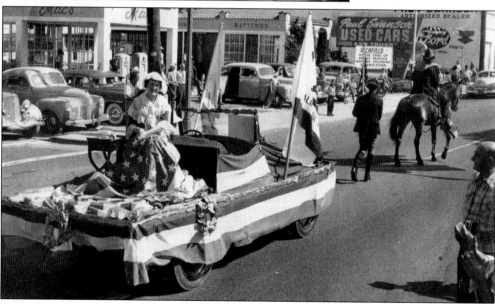

DAUGHTERS OF THE AMERICAN REVOLUTION. The Los Gatos chapter of DAR, organized in 1929, entered this float in the 1949 centennial parade. It harkens back to the 1776 Constitutional Convention in Philadelphia. Mrs. Walter Mueller played Betsy Ross, sitting beside a 200-year-old table and holding an 1860s 34-star flag. Paul Revere (played by Laurence Casaletto) rode ahead, followed by minuteman Ted Lockwood. Paul Swanson Ford is seen at 130 North Santa Cruz Avenue. (Courtesy Los Gatos Chapter DAR.)

WILDCAT CONNECTION. During the early 1950s, Walt Disney (right) visited a number of parks to gather ideas for Disneyland, which opened in Anaheim in 1955. He was sure of one thing: He wanted a train to encircle his park. Disney stopped by Los Gatos to see Billy Jones's orchard "Wildcat" railroad, a narrow-gauge steam operation, and the two men became friends. They are seen here on the Jones ranch.

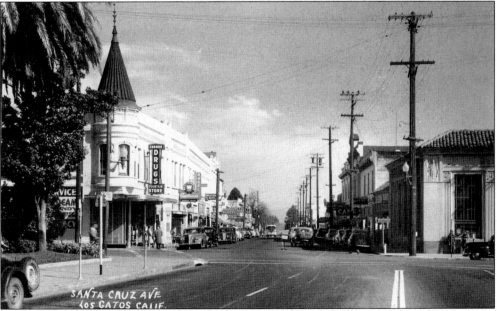

EISENHOWER ERA. This 1952 image shows a prosperous community, one worthy of its slogan: "When you think of home, think of Los Gatos." Up until World War II, the area remained primarily agricultural. The postwar boom saw the population of the town almost double. Between 1950 and 1960, it grew from 4,907 to 9,063. By 1970, the census count was 22,613, agriculture was on its way out, and Silicon Valley was on the horizon.

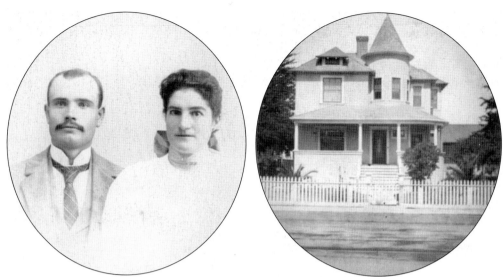

VICTORIAN ROW. The Kyle family home, completed in 1906, was located at 127 North Santa Cruz Avenue. It weathered the 1906 earthquake with only one chimney crack, but it was demolished in 1953. Located next to the Coggeshall mansion, it was one in a line of Victorians on the east side of the street. The young couple who built the house, William and Susie Walker Kyle, is pictured here. (Courtesy Elayne Shore Shuman.)

H AND L USED CARS. A month after the Kyle home was torn down, the land had been paved and Stanley Hopper was selling used Chevrolets from the location. (Courtesy Dick Shore.)

CHRISTMAS COWBOY. David M. Shuman, a fifth-generation Los Gatan, is pictured here in 1953. His cowboy outfit was probably inspired by the Westerns just appearing on television. Sometimes a living Santa Claus would be waiting to hear Christmas wishes in his sleigh at the town plaza. (Courtesy Elayne Shore Shuman.)

PAUL E. CURTIS JR. In 1954, Paul E. Curtis Jr. founded the Los Gatos Academy of Dance, an organization that later became the San Jose Dance Theater. His own training began when he was a student of Los Gatos legend Betty McClendon. Between them, they taught Los Gatos to dance. Curtis in shown here in the 1980s teaching at his Lyndon Avenue studio, which was built in 1927 as the Los Gatos Armory. (Courtesy Paul E. Curtis Jr.)

TOUGH STUFF. The 1906 concrete and stone Main Street Bridge survived the earthquake just weeks after it was completed, suffering only one cracked pillar, which was quickly patched. When a new bridge was planned in 1954 as part of the streamlining of Highway 17, engineers had a challenge, as can be seen here. The old span, built with hand labor and teams of horses, came down with the help of some dynamite. (Courtesy Lena Barbieri Conley.)

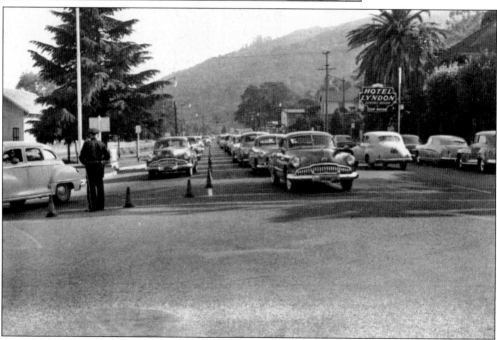

COMING IN. This snapshot of traffic coming into town from Highway 17 was taken in 1954. Summer days caused serious traffic snarls until a bypass was built in 1957. (Courtesy Lena Barbieri Conley.)

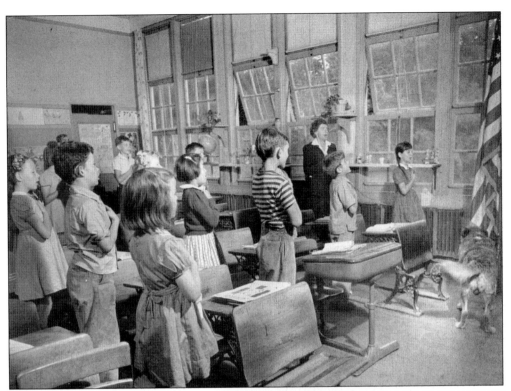

A Dog with Class. Chief, the town dog, arrived at school at 8:30 a.m., in time to line up at the door of Macy Williams's fourth-grade classroom with his "classmates." After standing for the Pledge of Allegiance, he would curl up in an aisle, where everybody had to step over him. The children donated pennies for his collar and vaccinations. Chief spent his nights on the porch at the Hotel Lyndon.

The Way We Were. The 1903 Carnegie Library was crumbling by the time it closed in 1954. Library services moved to the former American Legion War Memorial building on East Main Street, shown here. The current library has a storage area called the Flower Room, apparently because the floral society supplied some of the books (and bouquets of flowers) for the first town library in 1898. The card catalog has gone the way of the rotary phone.

OLD HOME PLACE. Irma Lyndon Farwell (1880–1964), seen here at the right, stands in front of the Lyndon Heights carriage house around 1955 with her daughter-in-law Louise Bacigalupi Farwell. Irma Farwell was the daughter of John and Theresa Lyndon. She married J. D. Farwell on April 30, 1902, at St. Luke's Episcopal Church. The carriage house's cupola now sits atop the bandstand in Oak Meadow Park. (Courtesy Farwell family.)

LOS GATOS PARENT NURSERY SCHOOL. This school, incorporated in 1946, was a popular cooperative effort. In 1947, it moved to a converted residence at 15 Lyndon Avenue. The building burned down on October 15, 1967, a case of arson by a local 14-year-old boy. It was rebuilt at the same location. This c. 1958 photograph by Robert Overstreet shows Claudia Ball (second from right), a great-granddaughter of Zephyr Macabee. (Courtesy Claudia Ball Tomlinson.)

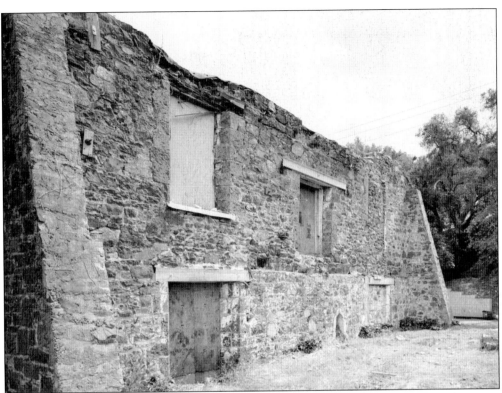

FULL CIRCLE. Most of Forbes Mill, constructed from 1853 to 1855, was torn down in April 1916. What remains is the 1880 annex, built of rough-hewn sandstone blocks. This photograph was taken by Jane Lidz in 1980, shortly before the annex was restored in 1982. In 1883, the flouring mill switched from grinding stones to rollers. Dr. Frank Knowles had one of the big stones hauled by mules to his ranch, where it was cemented into the landing of his back step. It was eventually chiseled out, and neighbor Lyman Bergtold preserved it by moving it to his Placer Oaks Ranch. He knew the importance of the millstone to Los Gatos history, and he imparted that knowledge to his sons, Phillip (left) and Chuck (center). Along with Chuck's son Brian, the Bergtolds restored the stone to the mill in 2005.

ACROSS AMERICA, PEOPLE ARE DISCOVERING SOMETHING WONDERFUL. *THEIR HERITAGE.*

Arcadia Publishing is the leading local history publisher in the United States. With more than 3,000 titles in print and hundreds of new titles released every year, Arcadia has extensive specialized experience chronicling the history of communities and celebrating America's hidden stories, bringing to life the people, places, and events from the past. To discover the history of other communities across the nation, please visit:

www.arcadiapublishing.com

Customized search tools allow you to find regional history books about the town where you grew up, the cities where your friends and family live, the town where your parents met, or even that retirement spot you've been dreaming about.